RUSSELL DRYSDALE

RUSSELL DRYSDALE

GEOFFREY DUTTON

144 illustrations
28 in colour

THAMES AND HUDSON · LONDON

© 1964 THAMES AND HUDSON LIMITED LONDON
THIS REVISED EDITION REISSUED IN
THE WORLD OF ART LIBRARY 1969
PRINTED IN GREAT BRITAIN BY JARROLD AND SONS LIMITED NORWICH

500 18098 9 CLOTHBOUND
500 20090 4 PAPERBOUND

Contents

Acknowledgements

My thanks are due above all to the artist himself, Russell Drysdale, who gave so much of his time and attention to the manuscript and to the arrangements of the plates.

My thanks are also particularly due to the artist's daughter Lynne and her husband Mr W. McLaughlin; to the Director of the Art Gallery of New South Wales, Mr Hal Missingham, and to Mr Daniel Thomas for permission to reprint in a slightly enlarged version their admirable bibliography compiled by Mr Thomas for the Catalogue of the Retrospective Exhibition of 1960; to Sir Edward Hayward for making available in advance the catalogue of the Retrospective Exhibition held at John Martin's Galleries in 1964; and to Mr Donald Friend and the late Professor Jock Marshall for their assistance in gathering material for the book.

I am most grateful to the Directors of the Art Gallery of New South Wales, the National Gallery of Victoria, the National Gallery of South Australia, the Queensland Art Gallery, the Tasmanian Museum and Art Gallery, the Western Australian Art Gallery, the Tate Gallery, and to all the other owners of works who have given their kind permission for them to be reproduced in this book.

Photographic credits are due to John Pearson, Pty. Ltd, Sydney; Nigel Buesst, Melbourne; Colin Ballantyne, Adelaide; Max Dupain, Sydney; Ritter Jepperson, Melbourne; John Webb, London.

From Countryman to Artist

Russell Drysdale is an Australian artist who likes to paint his own country, his own people, and the descendants of those aborigines who inhabited Australia long before his own people came there. But like all good artists, he belongs to the world, and it was the European tradition that moulded his technique; his painting attains a universal quality through a complete artistic assimilation of its local ingredients. Drysdale is a slow, stubborn and solitary painter of unshakeable integrity, and his own loving vision of Australia (which country is in size a continent and therefore able to support quite a number of different visions), is entirely his own. However, the word 'vision' also has the meaning of an imaginative anticipation, or a supernatural insight or foresight; it is this vision that gives truth to the paradox that nature often seems to follow art. There are now many occasions on which an Australian can find himself in front of a man, a town street or a deserted landscape and say, 'That's a Russell Drysdale', not because the shock of recognition comes from any particular oddity, but because the artist has seen, beyond the dusty surface, the hard forms that will endure.

This power to anticipate and modify gives Drysdale, in his own country, the status of an old master, of one who is now part of the visual history of Australia; outside his own country it gives his work that singularity, devoid of freakishness, which always accompanies the old master qualities of confidence and solidity.

The swift growth of Australian art in the last twenty years is an intensified miniature of what has happened in European art in the last sixty years. Once art historians talked in terms of Quattrocento and Cinquecento, now they are obliged to count

the decades. In Australia the danger is rather that the eager critics may be watching the minutes. There had been a slow accumulation of good and sometimes brilliant work in the first one hundred and fifty years of Australia's history, but since the 1940s there has been such a flowering of talent that by now such artists as Dobell, Drysdale or Nolan have an almost legendary distance of achievement.

One less fortunate result of this exciting activity has been that a double load has been imposed on Australian artists.

Firstly, there is the mood of the twentieth century itself, where in art so much falls under the great and dangerous shadow of Picasso, with his marvellous passion for innovation, and where in ordinary life technical progress leaves cars, refrigerators or bombs swiftly outmoded. Secondly, in a 'new' country like Australia the process of development, whether of a city, a countryside or an art form, becomes so exhilarating, once results are seen, that both present balance and future results are forgotten. Such impatience can be good fun, but it is not very satisfying; one is reminded of Rousseau's mistress, Thérèse Le Vasseur, making love to Boswell, 'like a bad rider galloping downhill'. Australian artists are continually being pressed, not only to make new paintings but to make ones that are different, an 'advance', a new 'series'. Meanwhile, as an ironic background to such 'progress', the bulldozers are busy knocking down an old stone bank in preparation for the building of a new one in glass and aluminium, or a corner of terraced cottages is making way for a petrol station. And behind the artists already established are a host of new ones anxious to claw their way into the booming world of art sales.

Drysdale is an artist who started late, and whose development has been slow, narrow and deep. He should be encouraged to go on painting in his own way into a fertile old age, as far as anyone is to be allowed to live that long. Fortunately, having weathered the storms of the last fifteen years, he is almost universally respected and admired by other Australian painters, both young and old, which of course is not to say that he is

8

necessarily having any influence on their work. Interestingly enough, it is the very painters whose work is most different from his own, young Sydney abstract painters like John Olsen, Robert Hughes or William Rose, who give the calmest and most honest appraisals of Drysdale's work; they know what he has done for their profession, that the very ground they work on was built by him and a few others. Australian art today is somewhat akin to a fleet of jet aircraft operating from runways built on a reclaimed swamp; a few years ago nothing at all would have got itself airborne from such a place. Only as recently as 1949 storms of protest burst out when Drysdale's *Woman in a Landscape*, now a classic of Australian art, was awarded the Melrose Prize in Adelaide, the painting having just hung peacefully for several weeks in the Macquarie Galleries in Sydney. But in 1964, one of the major attractions of Adelaide's extremely successful Festival of Arts was a large retrospective exhibition of Drysdale's work at John Martin's Gallery. *Ill. 51*

Drysdale has nearly always stayed aloof from arguments about his own art, but he cannot help being implicated in the perennial arguments about the nature of the Australian experience, the Australian legend, the 'real' Australia which so often waste the time of all concerned, but which nevertheless in expert hands are so necessary as a form of national stocktaking.

The Nullarbor Plain may have the longest straight railway line in the world, but there is no dead end like the back of beyond. The Bush, the Outback, the Great Australian Loneliness, no area gives rise to more tired clichés and more tenuous misconceptions. Most Australians, pullulating in their cities, never see it and would be bored by it if they did; an exception is the Alice Springs and Ayers Rock area, where it is safe to go on a guided tour. Englishmen like D.H. Lawrence or Douglas Pringle tend to be terrified of it, even when facing it a few miles from a capital city. Recently there was a spirited exchange in the columns of *Australian Book Review* between Pamela Hansford Johnson in England and Max Harris in Australia on the relation of Australian art to the empty spaces and the

9

'blinding loneliness' of the Australian continent, Pamela Hansford Johnson maintaining that this sense of isolation was the essence of Australian art, Max Harris replying that most Australian painters are a gregarious and cheerful bunch of city-dwellers who would rather stay within a taxi-ride of King's Cross or Carlton.

Of course there is some truth on both sides. The present tendency among Australian intellectuals to insist on the predominantly urban nature of the Australian people is justifiably overdue; the swaggy, the bushranger, the explorer and the noble bushman have wandered the tracks long enough; the Landrovers and the bulldozers are now pushing them a bit too hard. But certain characteristics have, rightly or wrongly, been assimilated from the bush by urban Australians, and also there is no denying that those thousands of empty miles are still behind the backs of every Australian city-dweller. As recently as Christmas 1963 a family of five died of thirst on the Birdsville Track. Any Australian who has visited the United States, a country about the size of his own, must be astonished to travel on and on, from great city to great city, across a predominantly fertile landscape; the rhythm runs east and west, north and south, but in Australia there is a centrifugal pull. Perhaps this may explain the fascination of Alice Springs, a precarious holding-point at the centre.

Amidst these various arguments Drysdale suffers from what is also one of his greatest assets, the fact that almost alone amongst Australian artists he is a countryman. (Sir Daryl Lindsay, another rare exception, once said to Drysdale when they were together among a large group of artists: 'You know, you and I are the only blokes here who would be able to cope with a mob of bullocks.') Drysdale was raised in and intended for station life. He accepts the outback with a countryman's calm and resourcefulness, just as he accepts without any illusions but with a genuine sense of comradeship the station hand, the drover or the aboriginal stockman. Young city-dwelling painters like John Olsen or Robert Hughes say, with a dis-

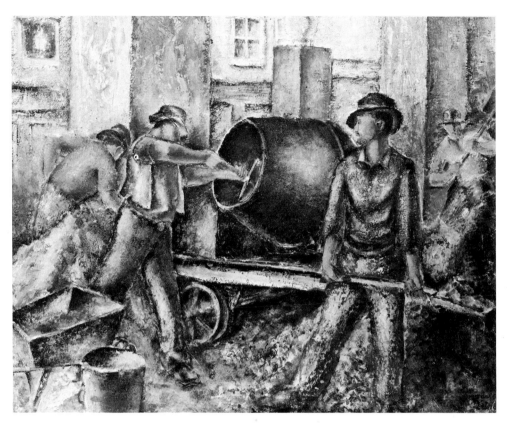

2 *Men Mixing Concrete*, 1937

approval that is not without affection, that Drysdale is senti-
mental about such people. Their generation is unforgiving of
any sentimentality, but to be swayed by sentiment (as Drysdale
undoubtedly is) does not necessarily mean that the emotion, or
the sentiment, is superficial. In many profound ways Drysdale
belongs with the country-people he loves to paint and draw,
though he is also discriminating enough to know that they
would be shocked if he were to take out his pencil on the spot
and draw them; carefully he takes their image home and puts
it down from memory.

The themes of loneliness, freedom and identification with country-people are basic to Drysdale's work and will be discussed later at more length, but it is essential to say immediately that Drysdale's relation to the figure in the landscape is a very complex one. He is indeed a great painter of loneliness; it would be hard to find a greater one in any country at the present day. But this is not the loneliness of alienation, of the stranger in a hostile land. It is an internal spiritual and emotional loneliness, for which Drysdale finds compensation in the freedom of Australian landscape and the strength implied in the ability of those who live there to survive in such an environment. The recurrent qualities of the lonely figures in his empty landscapes are those of calm, dignity, patience and compassion (especially in studies of mothers and children, white or aboriginal); there is also, most emphatically, though not in so many paintings, humour. Drysdale presents a simple and genial exterior to the world, but despite a relatively secure financial background he has had periods of great difficulty and unhappiness in his life, and the qualities he projects into his paintings are those he hungers for most.

In his very self he reflects the divided nature of his homeland, with its emptiness and its cities, for he is a countryman who has lived for the last twenty-five years in the heart of Sydney, a symbolic sight being this solid figure in a red check shirt driving along in his Landrover, looking as if he were heading for the Kimberleys, but in fact passing through King's Cross, the tiny heart of cosmopolitan Australia, to visit his daughter at Bondi Junction. He cannot live in the places he paints, and he cannot (or rather, does not want to) paint the place he lives in. There is something about Drysdale that reminds one of the remark an old shearer made about Joseph Furphy, author of *Such is Life*: 'He is of us, but not one of us'. Drysdale may be sentimental in some senses of the word, but he is too intelligent not to know that his genius sets him apart from the very people he belongs to and mixes with so well. They have the permanence, the sense of belonging, denied to him, and when he paints them the

loneliness of his own deprivation as well as the strength of his identification comes through. His favourite reds and browns are the colours of the blood and earth that both bind him and cut him off. The feminine blue of sky, or the softness of clouds, are seldom allowed to intercede or bless.

Sidney Nolan once said to the present writer: 'In the only sense that matters, Tassy Drysdale is the most genuinely Australian of all of us.' This of course does not make him a better or a worse artist, but it is interesting that this seamless unity with his landscape and its inhabitants once again disguises a divided world within. George Russell Drysdale (his friends usually called him Tas or Tassy) was born on 7 February 1912 at Bognor Regis, Sussex, England, a place in name and location about as far as it would be possible to get from the painter's favourite haunts in the Kimberleys or Cape York. As a child he was shuttled to and fro between England and Australia, for among his ancestors both Russells and Drysdales had been noted pioneers in the pastoral and sugar industries in Australia. It is interesting to note that Drysdale's greatest contemporary in Australian literature, Patrick White, was born in London in the same year as Drysdale, also into a pioneer pastoral family and subjected to the same early comings and goings across the world. The myth of Australia as a rough, tough, crudely simple country, built by good blokes, honest mates and ordinary workers, was never true, and none know it better than people like Drysdale and White.

Drysdale is very proud of his ancestors, and takes a practical part in managing one result of their labours, Pioneer Sugar Mills, on the Burdekin Delta in northern Queensland. The Russells went out to Tasmania in the 1820s; Robert was a clergyman there and George later acquired the famous Golf Hill property in the Western District of Victoria. In 1923 the Drysdales returned to Australia for good, sent Russell to Geelong Grammar School as a boarder, and in 1926 bought a station called Boxwood Park, between Albury and Corowa in the Riverina district of New South Wales. For six years

Drysdale stayed as a boarder at Geelong, spending the holidays in the Riverina, growing up contentedly in that superbly invigorating atmosphere of mingled freedom and responsibility which is the life – if the times and the country are not too hard – on the land in Australia. Joseph Burke, in his book on Drysdale, drew the parallel with Conrad's early life at sea, and it is a just one; the Australian jackeroo and the lad at sea both have to undergo harsh initiations, and the Australian land is almost as unforgiving as the sea. Likewise both worlds are masculine, do not tolerate eccentricity and leave culture limping after more practical affairs. Yet songs emerge from both, and anyone with a shred of soul must be stirred, unforgettably, by the contrast between elemental vastness and the tiny human who is both insignificant and supremely brave.

For the boy Drysdale, brought up by his parents to respect books and art and music, the mental climate at school was agreeable if not particularly stimulating. Geelong Grammar School has since become one of the most sophisticated schools in Australia, with magnificent departments of art and music; no such refinements existed there in the 1920s, and Drysdale grew up happily amongst his contemporaries, most of whom came from the country like himself. There was only one flaw in his make-up, that of his own eyes. Edmund Wilson, in his essay on the *Philoctetes* of Sophocles, 'The Wound and the Bow', traced one classical source of (in Wilson's words) 'the idea that genius and disease, like strength and mutilation, may be inextricably bound up together'. One need instance no more than the dwarf Pope, the cripple Byron, the deaf Beethoven. Blindness, however, is traditionally associated with poets, from Homer to Milton. Blindness for a poet, like deafness for a musician, is a form of torture; for a painter it would be death, unless he took to sculpture, where his hands could see. Drysdale's eye trouble began in 1929 and did not end even in 1935 when he finally lost the sight of one eye. Philoctetes' wounded foot stank so much that his companions deserted him; Drysdale's eye caused him to be rejected repeatedly for military service in

the war, to which many of his friends went and where one of the closest was killed. Another (the artist Peter Purves Smith) died afterwards as a result of an operation for tuberculosis contracted in the Burma campaign with Wingate's Chindits. It is all very well to say that it is unreasonable for a man with such a history of eye trouble to be upset at being rejected; men, let alone artists, are not reasonable. Finally, apart from everything else, the loss of one eye must continually emphasize the vulnerability of the other.

The closer one studies Drysdale the more cracks one discovers in his mask of the sturdy, simple Australian country boy. The immediate result of his eye trouble in 1929 was lengthy and boring medical treatment which resulted in the end of his days at school. He went to work for six months as a jackeroo at

3 *Life drawing*, c. 1937

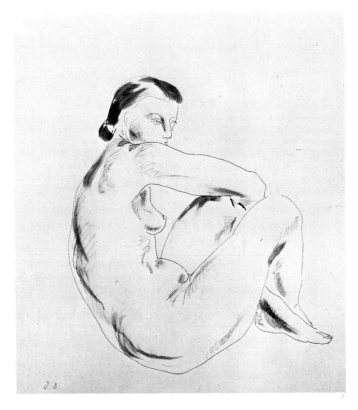

Pioneer, the sugar estate in Queensland, where he liked the life (he still does) and his uncle Cluny Drysdale so much that he thought of staying there for good. But his family went to England in 1931 and he was brought down to act as overseer on the Riverina property, later joining them in England for a few months. While he was there Cluny died, and he decided to continue as a jackeroo in the Riverina. In 1932 his eye worsened, and he was ill in hospital in Melbourne for a long period. With nothing to do, he amused himself by drawing, as he had often done before. He had always had a great admiration for the illustrators of the books he had read as a boy, from *The Boys' Own Paper* and *Chums* to Dickens, artists like George Soper, Stanley L. Wood and Caton Woodville, together with greater ones such as 'Phiz'.

His doctor, Julian Smith, a remarkable man in his own right, thought the drawings quite outstanding and showed them to his friend Daryl Lindsay (later Director of the National Gallery of Victoria). Sir Daryl, as he is now, was extremely impressed; he still remembers them, instancing one in a sketch book of a man outside a pub which showed a curious sensitivity and a sharp observation. Drysdale, who has always been an excessively modest man, asked Lindsay if he thought he could ever draw well enough to be the cartoonist on the Melbourne *Herald*; Lindsay showed them to Sir Keith Murdoch (a notable patron of modern Australian art, and later of Drysdale himself) who declared that the boy had not sufficient talent to aspire to such heights. Lindsay, however, sent him to George Bell, who has been the most successful art teacher in Australian history. Drysdale showed Bell a lot of sketches of illustrations to Dickens; Bell told him they were well drawn but hopelessly indebted to 'Phiz', and that he had better go away somewhere and learn to be original. It was brutal advice, but, as Bell says, that is just what Drysdale did do. Bell also showed him reproductions of Post-impressionist paintings, and especially those of Modigliani and Picasso. Drysdale was baffled by these, but was spurred on by Bell's further advice that he had it in him to be

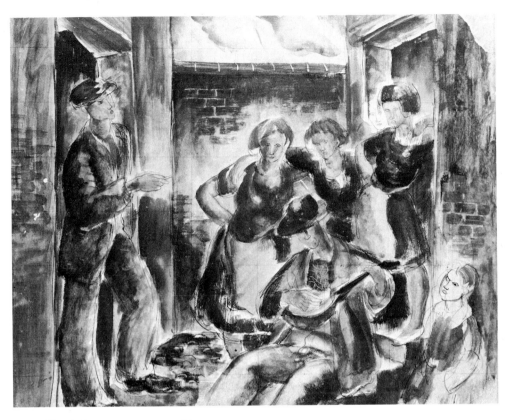

4 Sketch for a tempera composition, 1937

a professional artist if only he would go away and find out what it was all about. Drysdale fortunately went on family business to England and Paris at the end of 1932; Bell recalls receiving a very long letter from him apologizing for his ignorance and explaining his formative discovery of the world of modern art, from the Impressionists to the Post-impressionists to the School of Paris.

Even though Drysdale returned to his life on the land in 1933, his short period of study with Bell and the paintings he had seen in Paris altered the whole direction of his life. He was determined now to study art, and his parents, influenced by

Daryl Lindsay's enthusiasm, supported him, regarding it as akin to the support of a son learning a profession at a university, and paid him an allowance to go to George Bell's school. This must rank as one of the most important years in Drysdale's life, for he also married Elizabeth Stephen (likewise of pioneer descent), and finally lost the sight of his left eye, after an operation which attempted to restore vision lost by the detachment of the retina. He was now twenty-three, and felt that he had wasted years in discovering himself. One of his closest friends in later years, the artist Donald Friend, has suggested to the present writer that it may well have been the fear of total blindness that at last precipitated this self-discovery. Drysdale and Bonny (his wife's nickname) went to live at Eaglemont in Heidelberg, where Roberts and Streeton used to paint.

Drysdale was extremely fortunate in having George Bell for a teacher. Of the three leaders of modern painting in Melbourne in the 1930s, William Frater, Arnold Shore and George Bell, the latter's influence was by far the most important. By the mid-1920s he was an established academic painter, but he had a remorseless conscience that made him distrust success and hunger after further truths. In 1934, in a commendable exercise in humility, this established artist in his fifties went to Europe to learn about modern art, even going so far as to enrol as a student again, at Iain Macnab's school in London. What is more, he really did learn, at that most difficult stage when learning is relearning. Basil Burdett, one of the few good art critics in Australia in the 1930s, wrote in 1938: 'George Bell, a recruit to modern ideas from academic ranks, is undoubtedly the leader of conscious modernism in Melbourne today, and the major influence on the younger generation through the school he continues to conduct. An early associate of men like Lambert and Connard, a dweller in Chelsea for many years and an accomplished realistic painter, George Bell's conversion to modernism was slower but even more complete than Shore's and Frater's. It was a conscious intellectual process, carefully reasoned by a keen artistic and general intelligence. He has been

18

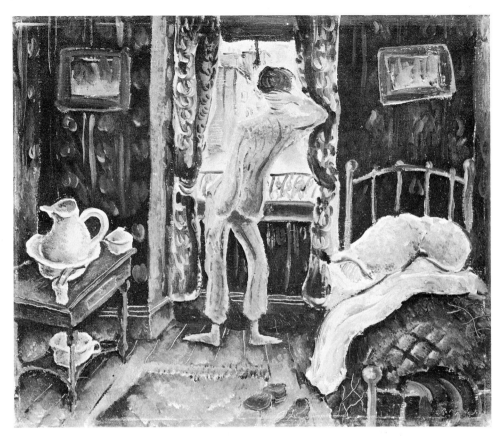

5 *Monday Morning, 1938*

interested in every aspect of modern art. The chief influence on his own work up till a few years ago was Modigliani. A period at Iain Macnab's school in London helped greatly to sort out his ideas and put his work on a firmer basis. Although it is based still on a rather severely simplified rendering of form – he occasionally produces an abstract work – his recent work, which is much more personal in character, combines a much greater degree of naturalism with an essential formalism than previously.' (*Art in Australia*, 15 November 1938, p. 15.)

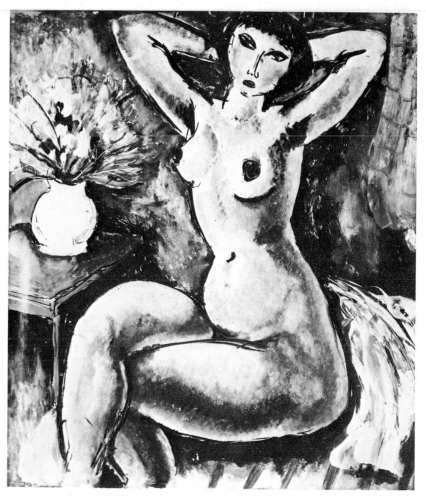

6 Nude, 1939

These are some of the qualities he instilled into the young Drysdale, but perhaps his greatest virtue as a teacher was that he imposed no style of his own on his students, however firmly he guided them, as a glance at the diversified work of some of his best pupils, such as Peter Purves Smith, Sali Herman or Drysdale, will clearly show.

But Bell, in his enthusiasm for modern art, by no means had the support of many people in the art world, let alone the general public. As Adrian Lawlor, the most brilliant polemical writer of the time, wrote: 'Mr Bell obviously had nothing to "gain" in repudiating standards under whose aegis he could have commanded commercial profit. He had, indeed, much to lose in espousing as fearlessly as he did an artistic cause which he knew to be, to say the least of it, unpopular. But Mr Bell has stuck to his guns and taken whatever obloquy the profession of his beliefs may have involved, with a grit and loyalty which it would be merely impertinent in me to applaud. That he inspires nothing but admiration among those of us who believe that the life of the mind is of more value than worldly success, is possibly the only reward that he will ever collect.' (*Arquebus*,

7 *Nude, 1938*

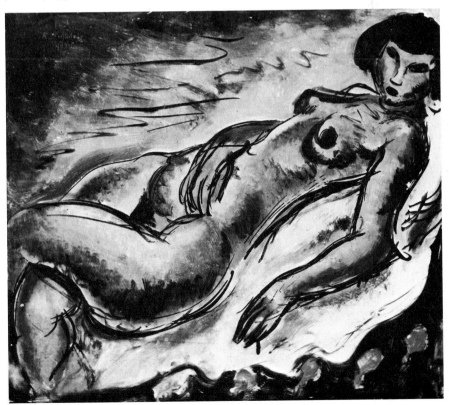

p. 47.) In view of Drysdale's own integrity, that of his teacher is worth stressing.

When Drysdale first enrolled at the school in 1935 he was taught by Arnold Shore, since Bell was still away overseas. However, Bell took over on his return and for the next two years his influence on Drysdale was profound. Amongst others at the school with him were Herman and Purves Smith, already mentioned, Mary Alice Evatt, Geoffrey Jones, Alan Sumner and Eric Thake, the last-named being the only one painting anything that might now be called a pure abstraction. The fellow-artist who influenced Drysdale most was the wanderer Ian Fairweather, then in his forties and fresh from China and Indonesia. The figure studies he was painting at that time were already invested with that superb unity of tone that characterizes his later work, but were chiefly remarkable for a sweeping line that had moved on from Modigliani to a fresh sensual quality where colour flowed over form like honey over marble. In a *Ill. 6* nude painted on glass at this period, in 1939, Drysdale has allowed himself the delight of following a curve but has achieved his teacher's aim of pure structure devoid of frivolity. There is little emphasis on colour except as it delineates form; *Ill. 4* the sketch for a tempera composition in 1937, when compared with the destroyed final composition (reproduced in *Art in Australia*, 15 November 1938, p. 43) shows that the rhythms were all-important and that little extra solidity was given them by colour. This is especially true of the beautiful interlocking of the figures of the three girls, remarkable work for a student with only two years' background. But one can say of the early *Ill. 8* paintings such as these and *The Rabbiter and his Family* that the basic solidity is as yet unmarried to a unity of design or purpose. The simplicity of the rabbiter's boots or his wife's slippers does not belong with the mannerism of their faces, and the eldest child looks as if he has strayed in from a ballet. Committed as he is already to the figure at some moment of existence, whether active or at a pause, Drysdale is not yet mature enough to understand the drama of that existence.

22

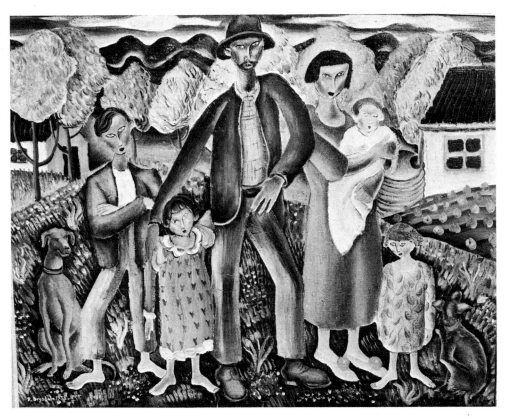

8 *The Rabbiter and his Family, 1938*

Basil Burdett, writing at this time, saw the quality of Drysdale but at the same time was aware of the dangers inherent in his present work: 'Much of his work has an imitative quality and he has still to find himself. His dexterity is marked and he is an inveterate experimenter technically. These qualities probably account for the air of somewhat superficial brilliance much of his work has.' (*Art in Australia*, 15 November 1938, p. 20.)

It was fortunate that at this crucial period Drysdale was able to go again to Europe to study under Iain Macnab at the Grosvenor School in London and under Othon Friesz at the Grande Chaumière in Paris, and to see afresh, with the eyes of

23

a practitioner, the work of Matisse, Braque, Soutine, Kisling, Derain and others. His daughter Lynne had been born early in 1938 and he took his family with him, joining his friend Peter Purves Smith in London.

He increased his reputation in Melbourne before he left with a student one-man show in April. This, whatever its limitations, was a good deal livelier than most of the work of Australian artists that had recently been sent to the Australian Pavilion at the Paris Exhibition of 1937.

The work in the Paris Exhibition was fairly representative of the dreary respectability and cud-chewing complacency of most Australian art at that time, and one can only guess at the wild liberation Paris must have been to the young painter by looking at what he had left behind him. *Art in Australia* for May 1937 printed six reproductions of works in the Australian Pavilion, five of them showing gumtrees leaning to the right, or to the left, or occasionally even vertical, with sheep presenting their backsides to the artist in three of the paintings. No wonder Drysdale's fellow-student, Sali Herman, a sophisticated Swiss who had emigrated to Australia, sighed: 'You either got sheep with gumtrees in between, or gumtrees with sheep in the middle.' The sixth reproduction was of an academic portrait that could have been painted anywhere in 1837. In the same issue of *Art in Australia* there is a short description of the Australian Pavilion, emphasizing the fact that 'Australia has more sheep than any other country in the world', and a review by that rabid hater of all modern art since 1880, Lionel Lindsay, referring to 'modernism' as 'a cretinous ideal'. At the same Exhibition, in the Spanish Pavilion, was Picasso's *Guernica*!

The same year, 1937, saw an attempt to form a Royal Academy of Australian Art, the guiding hand behind which was the Attorney-General, Mr Robert Menzies (later Sir Robert, Prime Minister of Australia). In his speech opening the Victorian Artists Society annual show of 1937 Mr Menzies said: 'You all know of the proposal to form an Academy of Art in Australia. I must admit that I was the prime mover in this idea.

9 *Girl with Still Life, 1939*

. . . Experiment is necessary in establishing an academy, but certain principles must apply to this business of art as to any other business which affects the artistic sense of the community. Great art speaks a language which every intelligent person can understand. The people who call themselves modernists today talk a different language.' Mr Menzies' language is easy enough to understand for anyone who has followed the history of new movements in art. For instance, the *Encyclopédie Contemporaine* for 25 October 1904: 'Monsieur Cézanne with his contrasting paint and his problematical drawing is a painter whom we shall never be able to understand; the enthusiasm that he had aroused in the new school will always be an enigma to us.' A tremendous row followed Mr Menzies' pronouncements; an early shot was fired by George Bell, who declared that there was little hope for backward Australia's artistic salvation while it was influenced by 'mentalities such as this'. Mr Menzies replied with an expression of such illimitable complacency that it deserves to rank as a classic text in any history of the battles that are fought over every new movement in art. 'I am a typical person of moderate education, I hope reasonably good taste, and a life-long interest in the fine arts. In other words, with all my individual defects, I represent a class of people which will, in the next 100 years, determine the permanent place to be occupied in the world of art by those painting today.' Adrian Lawlor, in the press and later in *Arquebus*, had tremendous fun with this pronouncement.

On the other side of the case to Mr Menzies, Mr Justice Evatt argued the importance of modern art, and above all urged that Australians might be allowed to see some. The chance came at last in 1939, when Sir Keith Murdoch brought a touring collection of modern art to Australia, selected by Basil Burdett, which was rightly described in *Art in Australia* as the most important exhibition ever to visit Australia. Within a few weeks of its opening over 40,000 people had visited it, but it was held in the Town Hall, not in the National Gallery, the Director of which (Mr J. S. McDonald) had distinguished himself by saying

26

in public: 'I don't think we should have modern art in the Gallery at all. It is not liked by the Art Galleries of Australia.'

This then was the artistic climate to which Drysdale returned in June 1939, just in time to exhibit with the newly formed Contemporary Art Society. George Bell had set this under way in 1938, and in July of that year it was founded with Bell as President, Rupert Bunny and John Reed, vice-presidents, and Adrian Lawlor, secretary. Unfortunately later dissensions fragmentated the original unity of the Society and gave rise to the virulent art politics of Melbourne in the 1940s, which did more harm than good to the cause of modern Australian art and was one of the reasons why Drysdale later moved to Sydney.

However, his work was well received in Melbourne in 1939 at the first C.A.S. show, which was opened by Mr Justice Evatt, and in terms of talent and the numbers of people who came to see it far outshone the exhibition of the Academy, in opposition to which the C.A.S. had first been founded. Gino Nibbi, an important if quiet figure in the Melbourne of the late 1930s and 1940s, who ran an art and book shop which sold large numbers of reproductions of contemporary European painting to Australians who had little hope of ever seeing the originals, wrote of Drysdale: 'The painter Russell Drysdale is fresh from European experience. His vision comes to a compromise between cubism and realism. We have been acquainted with this genre through the works of Braque and Picasso. But it is surprising how Drysdale succeeds in dominating the matter without overpowering it. The ingredients of his still lifes become elastic through his manipulation, and he deforms and alters their contours in order to kindle them to a vivid, plastic relief. In his work, the determination to isolate the colour reaches sometimes effects of lyrical incandescence.' (*Art in Australia*, 15 August 1939, p. 17.) At the end of the same article Nibbi attacked another conception of the Academy, namely that it could supply 'to some mystical soul the illusion that it is possible to lay the foundations for an art typically Australian. . . . In a creative sense, a local art could not help appearing

provincial, amateurish, crammed with all the inevitable senti-
mental anecdotes. Consequently, we must believe in Australian
artists rather than in a mythical Australian art, since contem-
porary history, because of the simultaneity of artistic researches,
no longer allows such a belief.'

These were prophetic words, and it is highly significant that
the work of the most 'typically Australian' of modern artists,
men like Drysdale, Nolan, Tucker, Arthur Boyd, came to
maturity in the 1940s under the fertilization of international
contemporary ideas in art, whereas the gumtrees of the
Academy simply fell down from senility and did not even go
up in a glorious blaze. It is an instructive paradox that Braque,
Soutine and the Surrealists led to *Native Dogger at Mt Olga*, *Ill. 101*
Picasso to the *Ned Kelly* series, and Chagall to the *Half-Caste*

11 *Still Life, 1939*

Bride series. Such a process was symbolic of Australia's coming-of-age in the 1940s, when international ideas, and embroilment in a world war, developed at last a national character that could be independent without being chauvinistic. The art and literature of the time both reflected and helped to mould that character.

One thing that was needed was a new vision of the land itself, and this Drysdale set out to find, in the private studio which George Bell lent him for a year. In his own words, he was attempting 'to work out first ideas of themes of life of the land, the experience of which has always remained strongest. Apart from McCubbin and Roberts in an earlier age, no one had portrayed the people and country of the great interior. Landscape painting had concerned itself with the pretty country, and Impressionism had degenerated to the maudlin. Bell, who had taught the principles of classicism in a post-impressionist

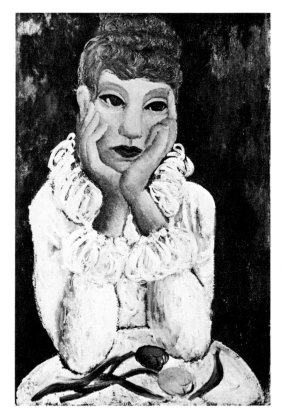

12 *Head of a Girl, 1939*

attitude had implanted a different outlook and tradition.' (*Catalogue to Retrospective Exhibition*, p. 14.) It is true enough that no one was painting the interior with the exception of Hans Heysen, an established artist who had nothing technically to offer Drysdale except good academic drawing, but who had, quite unknown to Drysdale, already been painting amidst the brilliant colours of the harsh landscapes of the Flinders Ranges in South Australia, and who had written in 1932: 'The far Northern interior of Australia with its stern reality of desert country holds a peculiar fascination for many who have come under its spell . . . I have seen it at various times over a period of some years, but always when the country was in the throes of severe drought . . . when the whole land seemed moving under my feet, and every object was obscured in dense dust. Again I have seen it on calm days of crystalline purity when the eye could travel, as it were, to the end of the world, bringing

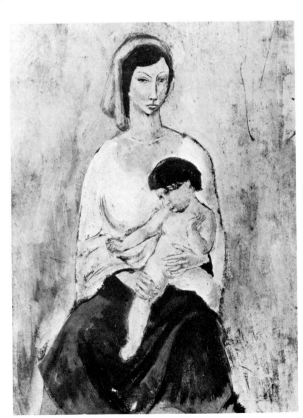

13 Mother and Child, 1940

with it that wonderful sense of infinity that a land of moist atmosphere could never give. There is an undeniable call about this interior which covers by far the greater portion of Australia, and offers, for the artist, a wide field as yet practically untouched.' (*Art in Australia*, 15 June 1932.)

Drysdale, however, in 1939 and 1940 was still far from painting such country. The painting which Gino Nibbi admired *Ill. 10* at the C.A.S. show, *Still Life*, and which Drysdale had brought back with him from Paris, was a confident arrangement owing some of its form to Braque and some of its colour to Matisse. Two figure paintings done in Melbourne after his return, *Ills. 12, 9* *Head of a Girl* and *Girl with Still Life*, are also essentially Parisian in their flat decorative paint and strong formal design, successful in their way but clearly an aftermath of the vitalizing experience of his European visit. The fruits of his coming to grips with new experience, the first true emergence of the splendour of an original genius, appear in the paintings of the decisive year of 1941.

14 The Newspaper, 1940

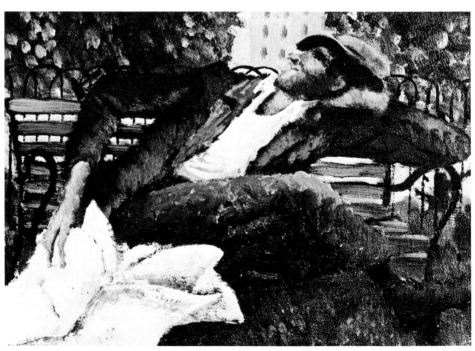

Painting in Sydney

As often with Drysdale, a disruption in his life was later accompanied by a growth in his art, analogous perhaps to the breaking up of soil before a seed is planted and grows. He has referred himself to the unsettling effect of the war, his own rejection for service, and the departure of many of his friends. Also the art quarrels of Melbourne depressed him and interfered with the private development of his work; he has never been a man to join schools or engage in partisan battles, and he has managed to keep an open mind towards artists very different from himself. In search of new freedoms, he left Melbourne in 1940 with his wife, daughter and son Timothy (born in that year), and settled temporarily at Albury with Bonny's parents. For a moment the old life caught at him again, together with the guilty if absurd feeling that he ought to be doing something more 'useful' than painting, and he acted as overseer for shearing at the property of a friend who was away in the army. But any ideas of staying on were dispelled by the realization that a firm of stock and station agents could do the job as well as he could, and he moved with the family to Sydney at the end of 1940, where he took a house in Vaucluse. He knew no one in Sydney, and was able to give all his time to painting. When he began to exhibit at the Macquarie Galleries, and his reputation began to grow in Sydney, he found that he 'made friends among the painters who all showed kindness and help to a newcomer'. He is still good friends with many of them, such as Sali Herman, David Strachan, Margaret Olley, Paul Haefliger and especially Donald Friend.

Man Feeding his Dogs is the starkest example of the new phase *Ill. 17* of development Drysdale reached in 1941. It could not be further from a painting, *Girl at a Window* (subsequently

destroyed, reproduced in *Art in Australia*, 25 November 1940), which he showed at the annual exhibition of the Contemporary Group at the Blaxland Galleries, Sydney, in August 1940. The earlier painting is of a plump-armed, buxom girl relaxing somewhat self-consciously in a chair by a window, surrounded by a Parisian potpourri of furniture, flowers, fruit and wrought iron. In contrast, the man feeding his dogs is dragging his lanky legs along between sky and earth, watched only by a distant figure whose sardonic attitude is reflected in the sole battered signs of human achievement, a broken cart-wheel against a tree, and a seatless chair tossed ludicrously high on a broken bough of another tree. Against this tired, dry setting the lean, long dogs quiver with impatience or leap and strain against the leash. The co-existence of energy and exhaustion is brilliantly conveyed, and the colour is as economical as the drawing. There are near-surrealist elements, partly assimilated from his friend Purves Smith (e.g. his *New York*), in the fantastic precision of the empty trees and the isolated pieces of equipment, but the painting, though not strictly realistic, is emphatically of a time and a place, using the basic elements of Australian landscape and life in an entirely original way. The elongated distortions of this and other paintings of this period are justified by Drysdale's conception of the sparseness, the spindly insubstantiality of man's hold on the enormous, flat, red Australian earth. Inside a dwelling, civilization has done little to make life less stark; in the little *Woman Sleeping*, dominated also by reds and browns, there are a few comfortable oddments lying about, but the picture is illuminated by the clash between the skinny brass bed above the long planks of the bare floor and the centrally rhythmic curves of the woman's full breasts.

The most celebrated painting of this period is probably
Ill. 15 *Moody's Pub*. Sir Daryl Lindsay recalls the difficulty he had in persuading the Trustees of the Melbourne Gallery to buy it for £40. Both the price and the painting brought outraged howls, especially from Max Meldrum; Lindsay replied that in his opinion it conveyed, apart from its merits purely as a painting,

34

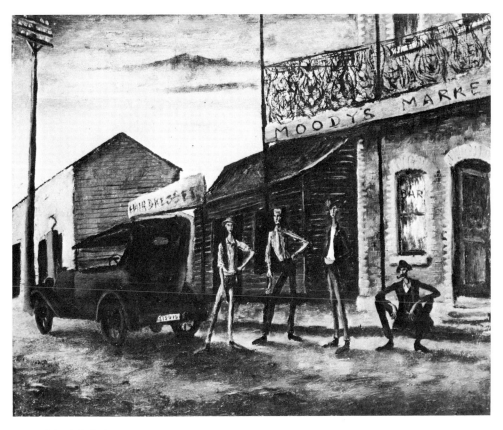

15 *Moody's Pub, 1941*

all the character of all the pubs he knew in the Riverina, and he finally told the Trustees that if they did not buy it, he would. *Moody's Pub* is one of those paintings, like the gaunt *Sunday Evening* (which was bought by the Art Gallery of N.S.W. in 1941) which gave rise to comparisons with painters of the American Middle West such as Thomas Hart Benton, Grant Wood or Charles Burchfield. Bernard Smith in *Place, Taste and Tradition* (1945) thought there was 'something of a counter-part' here, which in his *Australian Painting* (1962) he modified to the definite statement that Drysdale's sources were 'not to

35

be found in such work, but . . . in contemporary European painting'. John Reed, writing in the famous Ern Malley number of the periodical *Angry Penguins*, was more dogmatic: 'I find his interpretation of the Australian landscape essentially banal and insignificant, having an appeal which is superficial only, and that his lanky figures and gaunt stock – derived as they seem to me to be from American sources – do not satisfy one beyond their first impression.' The surprising touch of sourness here comes after the long and bitter quarrel Reed had with Drysdale's teacher, George Bell, over the Contemporary Art Society; Reed did not really care for any of Bell's pupils. Another factor was Reed's almost proprietorial championship of Sidney Nolan during the 1940s, in which it was impossible to like Drysdale if you liked Nolan, and vice versa – an antagonism certainly not shared by the artists themselves, as was demonstrated when

16 Man Reading a Newspaper, 1941

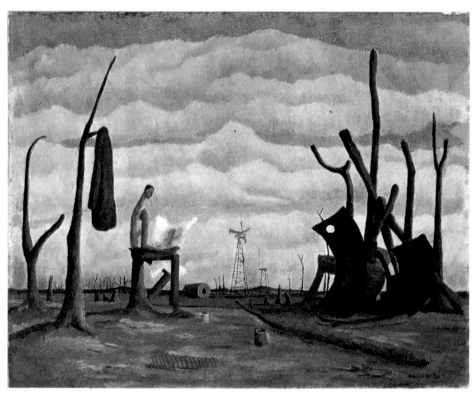

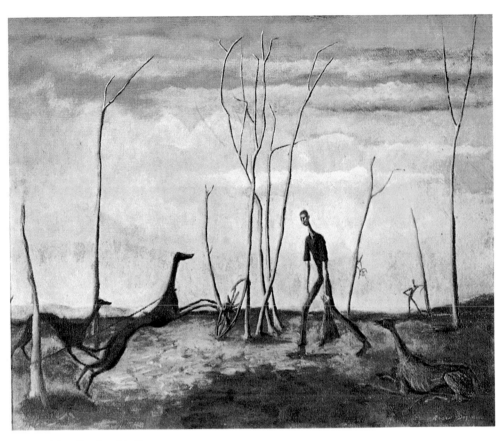

17 Man Feeding his Dogs, 1941

Nolan finally left Melbourne and went to live in Sydney where he sought Drysdale's advice and friendship. This trivial and specious rivalry left a scar on Australian art criticism which took some time to heal, and deepened that rift between Melbourne and Sydney which is partly a joke and partly genuine. The exclusivist tendencies operated on both sides; Drysdale was never mentioned in *Angry Penguins*, and the revised edition of Ure Smith's *Present Day Art in Australia*, published as late as 1949, dealt with forty artists amongst whom there was no mention of Nolan, Vassilieff, Tucker, Arthur Boyd or any of the significant Melbourne artists.

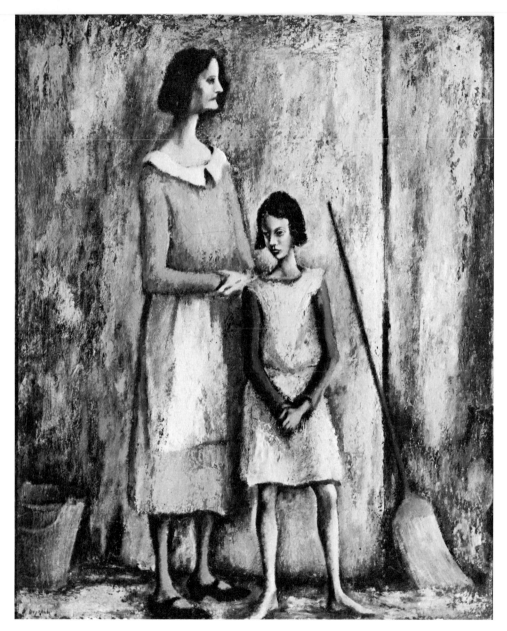

18 Mother and Child, 1942

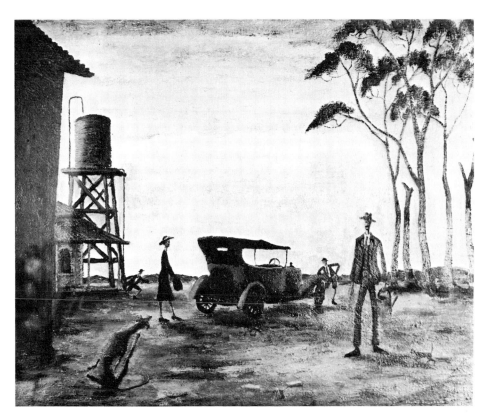

19 Going to the Pictures, 1941

John Reed was not correct in saying that Drysdale's work was 'derived from American sources'. Drysdale had seen no paintings of the American Mid-West group, and had no desire to do so; nor will anyone who has travelled in both the outback of Australia and the Mid-West of the United States find much similarity between the two beyond flatness and distance and dryness. What Drysdale had seen was the droughty face of his own country, especially in the Riverina after the bad year of 1940, and the pioneering attempts of his friend Purves Smith to use this material as a basis for new developments in Australian landscape painting. (See, for example, the painting *Drought*,

1940, reproduced on p. 242 of Bernard Smith's *Australian Painting*, where the gaunt, bare trees, the distance and the focal line of the horizon embody many of the elements of Drysdale's
Ill. 17 work such as *Man Feeding his Dogs*.) As for the gawking,
Ill. 15 slouching figures of *Moody's Pub*, they, despite the distortion, are quite obviously Australian, as is every detail of the painting.

In colour and in subject matter *Moody's Pub* exemplifies the direction of Drysdale's painting in the next few years, as may
Ill. 21 be seen by comparing it with *Local V.D.C. Parade*. Eschewing the movement of *Man Feeding his Dogs*, the artist uses a dramatic range of colour from blue to red to provide a strong contrast with the singularly undramatic subject matter. In such regions of Australia a great deal of time is spent just waiting around, whether by inclination against a pub verandah, or by necessity, as with the seasons. No countryman can hurry up the

20 *Back Verandah, 1942*

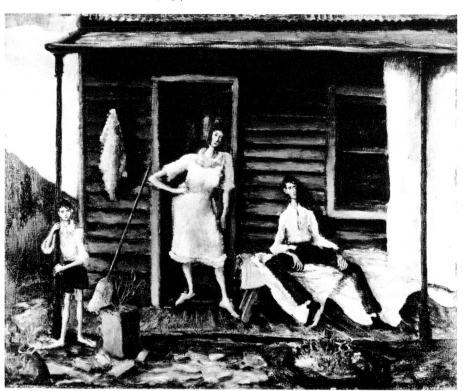

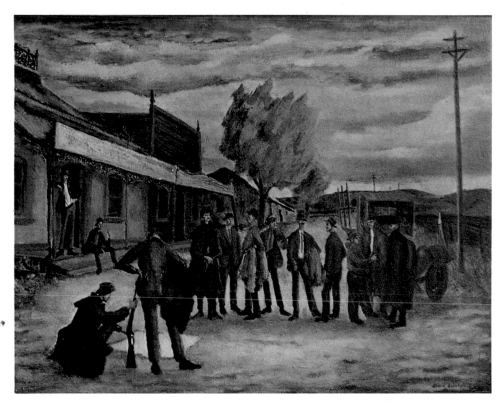

21 *Local V.D.C. Parade, 1943*

processes of nature, and nowhere is this more true than in country subject to drought. Nevertheless, the colours of the coming of night themselves are drama, as is the green that does come at last after rain, against the red earth. Thickening the light, and disposing his groups in expectant attitudes, even utilizing emptiness itself, Drysdale makes the future promise drama, even though the waiting moment offers none. The heroes of the Volunteer Defence Corps, armed with one ancient rifle between them, uniformed in nothing except the common scragginess of hats and coats, are just as unimplicated in action as the quartet of loungers outside Moody's pub; the presence of an enemy would astound them. It is the same with

22 *Albury Station, 1943*

Ills. 22, 23 the war paintings and drawings of this period, for instance *Albury Station* or *Albury Platform*, where exhaustion, emptiness and loneliness are evoked in order to suggest, not heroic qualities, but the boredom, the waiting and also the ultimate menace of army life. In Drysdale's later evolvement of heroic character the stoic ability to endure is a primary quality, and it is already present in these earlier subjects who would use the word hero only in strictly ironic terms. D.H. Lawrence, who was so very acute about some aspects of Australia, and so very English about others, refers in *Kangaroo* to 'a sort of ironical stoicism', which he thought basic to the Australian character; this exactly describes a favourite Drysdale *persona*.

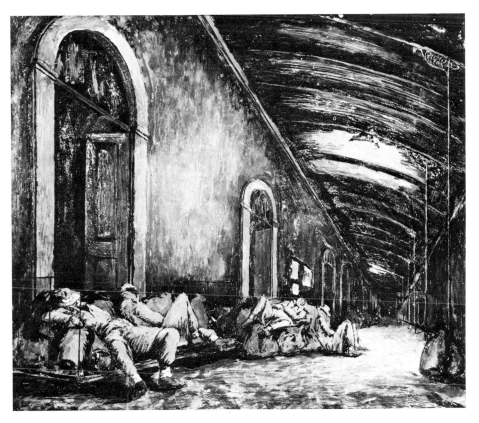

23 Albury Platform, 1943

It is worth noticing that the spaciousness of the paintings of this period does not involve the use of a large canvas; the average size is only about 20 in. by 24 in., if that, and they are often painted on wood. There are often reasons for such things, as artists are very practical people, and one reason here was the extreme scarcity of suitable canvas during the war. Drysdale is not a prolific painter, and he often destroys or paints over work he is dissatisfied with, but there is no doubt that some interesting paintings of the wartime period might have survived if Drysdale had not wanted the canvas to do something better; when it was not possible to paint over, he would boil the canvas in a copper and scrape the paint off.

43

In March 1942 Drysdale had his first one-man show in Sydney at the Macquarie Galleries, and it was successful enough for his name to be linked with that of William Dobell as giving Australian art a new strength and direction. He returned to Albury for about six months, with some thought of returning to the land to look after a sheep station but in the meantime painting hard in a studio rigged up in a barn in a paddock. Donald Friend, who was training at the time as a gunner in a military camp nearby, has recalled the sense of liberation he enjoyed on periods of leave which he spent painting or simply drinking and talking with the Drysdales. The arts are often thought to be dispensable in wartime, but Donald Friend's eloquent diaries are proof of how they belong to the life that endures, which the apparent realities of war do not. 'I go into [Albury] about twice a week. This is what I do. First, I eat an enormous underdone rump-steak, which makes me feel very happy. Then I go to the local club and have a few drinks, sometimes I buy a bottle of gin. After that I get a taxi and go to see Tas and Bonny Drysdale. Tas is a very good painter.

'Then we just talk, sitting by the fire, drinking the gin. The talk is quite the most glorious thing. It is like being in heaven to sit at peace by a fire, talking, and finding that you still have a mind that works sharply and easily, and that all the things you value are enjoyed and valued by other people. You find again a world with solid foundations. Because in the army all these things are not considered to have any existence at all. There the entire universe is based on axioms and superstitions that I cannot conceive as having the faintest relation to truth.

'So we sit and drink by the fire, and we talk, and I put on gramophone records, and for the time I am there I am once more moving among realities.

'These are my two lives now: the dream and the nightmare.' (*Gunner's Diary*, p. 17.)

In face of such testimony, it is good that Drysdale did not hunt further realities on sheep stations, but, pursuing his own,

44

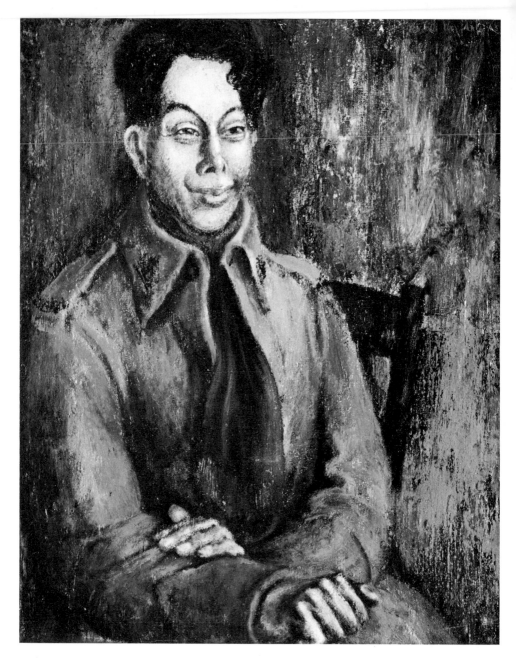

25 Portrait of Donald Friend, 1943

moved to live and paint in Sydney. Donald Friend has a heart-rending description of the hangover he suffered after the last 'beer and boogie-woogie' party at the Drysdales', who then moved to a house in Vaucluse where they lived and Drysdale painted for the next ten years. Once again Donald Friend, with the enthusiasm of one deprived of such things, gives the best description of life at the Drysdales'. 'Tass's house is lovely. There are miles of books. The first I looked through were some Vogues, and it was wonderful to see how the Vicomte de Leury had got his new cocktail bar done up – something like a tent draping from the roof in red satin, and the bar disguised as a Punch and Judy show. Then, after that, I read Gertrude Stein on Picasso, and dozens of other books. Here I can sit down in a lovely chair, and nobody makes me get out of it, and we talk if we want to, and go out or stay in, just as though life were a simple and beautiful business that allowed you to do what you like without anyone getting offended or upstage, or wanting you to go to the beach or some place when you really would rather be dancing the conga or looking at paintings or being rude to someone.

'I find it hard to believe I have so much peace.

'Tass did a couple of pencil drawings of me for a portrait he intends doing. While this was going on, we talked about some of the trends in work at the Contemporary show. *Ill. 25*

'I remarked that a whole lot of those politically-conscious paintings by those painters who are communists and what–not, curiously portray the workers as a most desperate half-starved, suffering lot. How revolutionary thought too often resolves itself into clichés – a point of view, however exciting and new at first, becomes widespread, and ultimately sterile and medi-ocre; life catches up on it, then possesses it, leaving it stranded.

'The slogan "Art is Propaganda" has been responsible for a lot of lousy painting.

'These "Revolutionaries" (self-styled) who so dully rant about the downtrodden proletariat. What they say of the present day would have been quite true of the depression years.

Tass has no political convictions. Nor have I: one is too sickened by the idiocies of both sides of the question. If I had, I wouldn't paint starving workers when unskilled laborers get up to £16 per week. The thing is laughable. It would be truer to portray them riding in taxis, but equally ridiculous.' (*Painter's Journal*, pp. 42–3.)

Friend and Drysdale have had a long and fertile association. Friend's sceptical wit has gone well with Drysdale's country-man's common sense, and the lighter touch of one has offset the darker moods of the other. Neither of them has ever fallen out of love with the human form as a subject for art, and Friend's brilliance as a draughtsman has been an encouragement for the same quality in Drysdale. In their approach to their

26 *Home Town, 1943*

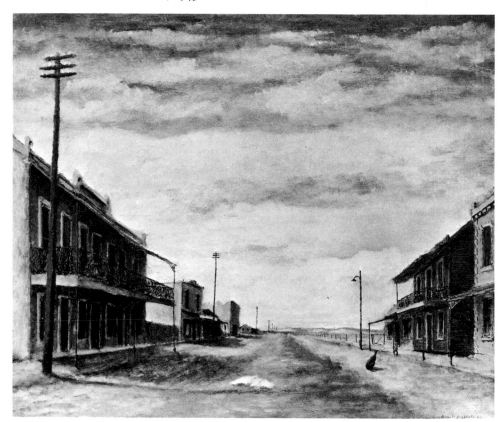

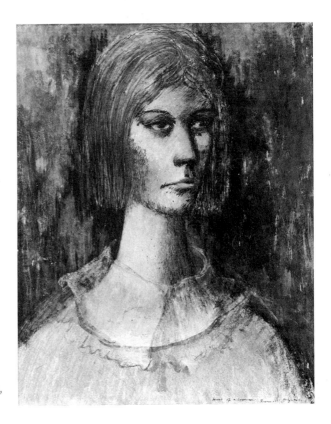

27 *Head of a Woman,*
c. 1942

work, however, they could not be further apart. Friend is a gay
and compulsive artist who, in whatever situation, simply could
not help drawing or painting; Drysdale, on the other hand, is
one of those artists who have to wrestle with the daemon
before beginning a new work, one who, with his country
background, loves the satisfaction of being embroiled in prac-
tical affairs, and dreads the responsibility imposed upon him by
his own genius. There have been many great artists and writers
who have confessed to the ingenuity with which they will put
off beginning a new work. Friend recalls Drysdale doing much
the same; on one occasion he came to the Drysdale's house
wearing a simple and comfortable pair of Indian sandals, and
forthwith Drysdale stopped painting and set to work to make
his children similar sandals.

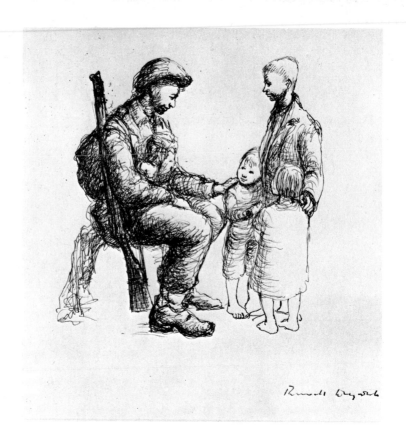

In addition to this, Friend always knew the sort of people
and places Drysdale wanted to paint, unlike someone like
John Reed ensconced in the city of Melbourne. Consider this
description: 'Today there are a lot of people in from the farms
– lanky gnarled farmers with their amply shaped wives in
sulkies and gigs – with their pink, scrubbed bulky young sons
(what enormous hands they have) yarning in the pubs about
their crops, the shortage of oranges, of horse-breaking, the
price of cattle, or rainfalls. The pink sons in uncomfortable best
suits and hard hats that stick straight on their heads listen,
uncomfortably self-conscious, silent, to the drawn-out yarns of
their seniors. They look like Van Gogh characters, fresh-faced,
strong, dumb, virginal.' (*Painter's Journal*, p. 83.)

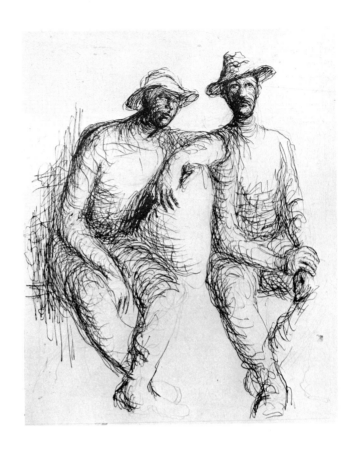

28
*Soldier with Three
Children, c. 1941*

29
Soldiers, c. 1943

It was not only a fresh aspect of the landscape that Drysdale discovered, but a new race of inhabitants as well, and Friend corroborates what he saw. Although, in the extract above, Friend is thinking of Van Gogh, not Drysdale, one can see a perhaps unexpected line of descent running back from the Australian to the Dutchman, right to Millet, the surety of that 'strong, dumb, virginal' existence of the figure in the landscape.

Whilst on the subject of Donald Friend – Drysdale was once saved from perhaps serious injury by his close acquaintanceship with the younger painter. At one stage Friend lived for some time with the Torres Strait natives, amongst whom he was accepted as a blood brother, and affectionately known as Duke Friend. On a visit to one of the most northerly and remote

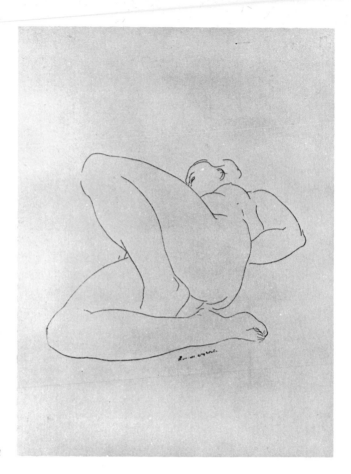

30
Nude,
c. *1941*

towns in Australia, Cooktown, Drysdale was walking back to his hotel at night when he was pounced on by the native crew of a pearling lugger, who demanded a bottle of rum. Drysdale (unusually) had no bottle available, and they were in a very ugly mood and not inclined to believe him. Suddenly Drysdale had a brainwave and asked them if they knew Duke Friend. Of course, they said, with a new respect, and when they heard that Drysdale was a friend of the Duke's their mood immediately changed, all was joy, and Drysdale was invited aboard the lugger. He not only went, but also managed to find a bottle of rum.

Friend and Drysdale saw through the pretensions of the fake social realism that had something of a boom during the war; at the same time, in Melbourne, Albert Tucker was assailing the Marxist dialectic that lay behind it and suggesting a more valid approach to contemporary problems of good and evil in society. The Melbourne painters attacked the cruel and disruptive reality of their times with an expressionist technique and a symbolic frame of reference (for example, Tucker's *Images of Modern Evil*, Arthur Boyd's hunted figures in twisted

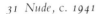

31 *Nude,* c. *1941*

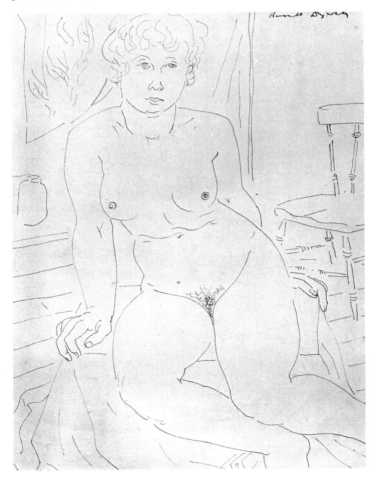

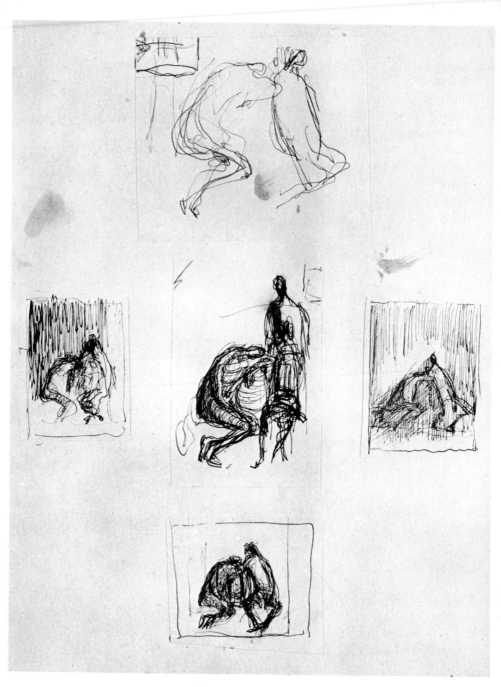

32 Sketches for Soldiers Resting

landscapes, Perceval's *Boy with Cat*, built of claw and cry), except for Nolan, who was making his way, *via* the Wimmera landscape, towards a transference to myth. Drysdale had already painted a new aspect of his environment and had extracted new truths in the process, when in 1944 his vision was deepened and strengthened by one of those periodic shocks which seem always to have had the effect of increasing his stature as an artist. 1944 was a year of appalling drought in western New South Wales, and, with admirable imagination, the *Sydney Morning Herald* commissioned Drysdale and a first-rate journalist, Keith Newman, to make a report on the drought areas. Drysdale had always been painfully aware of the nightmare of the war, and all that had led up to it (see, for instance, his friend Purves Smith's *Nazis at Nuremberg*), but he could not

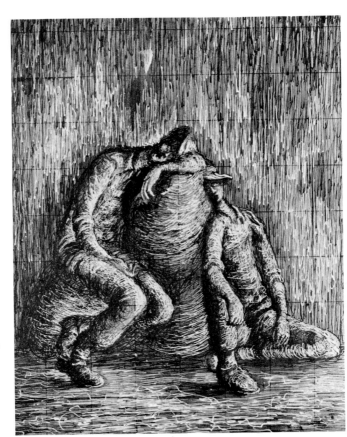

33
Soldiers Resting,
c. 1943

paint it without immediate, personal knowledge; now he was plunged into a nightmare that not only extended his range of knowledge but also his imagination, in the sense that an artist's imagination imposes new order on the disparate elements of his experience.

Before the paintings came the drawings, and although they were directly from something seen, they revealed shapes and significances that no one had divulged before. Drysdale's career as an artist had begun with his drawings, and they have never ceased to be interesting, especially as they do not always move in parallel with his painting. Sometimes he explores the different media of drawing for effects that could not be obtained in paint, sometimes he is making the common use of drawing as a preliminary to painting, and sometimes he is using drawing as someone less gifted might a camera, purely for a personal record. His studies of soldiers in the Albury period are clearly *Ill. 23* associated with the fuller treatment in a painting like *Albury Platform*, but their wound-round and interlaced line is something quite separate.

Spotting influences with Drysdale is always a dangerous *Ill. 33* game. *Soldiers Resting* would seem to have clear affinities with Henry Moore's series of people sheltering in the London Underground during air raids; in fact, Drysdale does not recall having seen these works of Moore at that time. A more likely source, if one were needed, might be Picasso's etchings of the nude of 1931. But a source is not really necessary. A page of *Ill. 32* little sketches shows Drysdale feeling his own way towards these final drawings.

It is the same with the eroded, hollowed shapes that inhabit the drawings made from the 1944 drought journey. Here critics have suggested the influence of Moore again, and of Graham Sutherland, but as with the alleged American influence, the influences come on both sides from an artist's imagination working on close observation of nature, rather than from secondary sources. It often happens that critics are much more aware of trends in contemporary art than artists are.

56

A New Vision of the Australian Land

Before Drysdale, Australian landscape painters had nearly all contented themselves with rolling in the lush pastures of the fertile regions of temperate Australia; Heysen in his Flinders Range landscapes was an exception, and he had been intent on rock and tree rather than on the interrelation between man and this harsh environment. Bernard Smith has pointed out that Drysdale was in fact extending the original tradition, especially in literature, of man facing a hostile and menacing land; he even made a good case for comparing Drysdale with Lawson.

34 *Ennui, 1944*

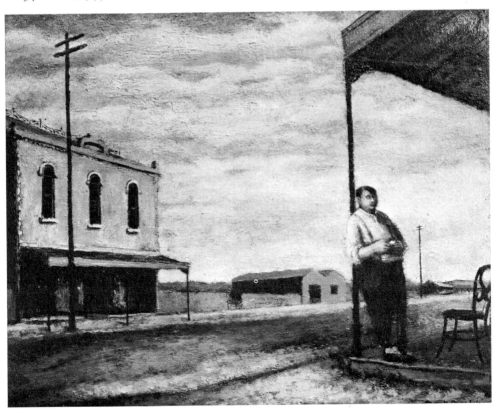

But Drysdale was also pioneering with form (so were Moore and Sutherland, hence the comparisons that have been drawn), and in the shapes of eroded tree roots, rock, sand, abandoned windmills, burnt-out farms, the vistas of verandahs, and the heavy-limbed people themselves, he imparted new rhythms to Australian painting and drawing, and, as if symbolically avenging himself for the lost sight of one eye, he taught Australians to see their country with newly awakened eyes.

In the face of such desolation, his lanky figures disappeared, giving way to stocky or statuesque people with the endurance of camels. Though he did not give up his thin, clear vertical tree-trunks for some years, he now discovered the horizontals of fallen trees whose exposed roots and broken branches grope like talons in the moving sand. The trees still standing, long dead, are clawed into what solid earth is left them. With the

35 *Dead Horse, 1945*

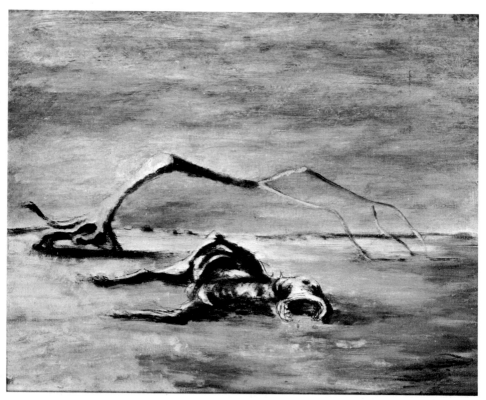

bones of trees go the bones of sheep and cattle, stripped clean; carcases are humped like distant mountain ranges under the dried skin, the remaining tufts of hair blowing like faraway trees, while the foliage of a dying mulga hangs down like hair. Human, animal and landscape become interchangeable symbols of disaster, as when the eroding sand lays bare an aboriginal grave and a sheep dies near the human skeleton.

This is sensational material, but Drysdale is too honest an artist to aim for the sensational and not to give the full picture. Newman and he found that amongst all these horrors the people just endured and showed no signs of giving up, and Drysdale draws a mother and a child who exhibit that mixture of humility and pride which is patience. In the earlier paintings there was a sense of arrested drama, of waiting for something menacing. Now the menace has long gone and the people are

36 Landscape with Figures, 1945

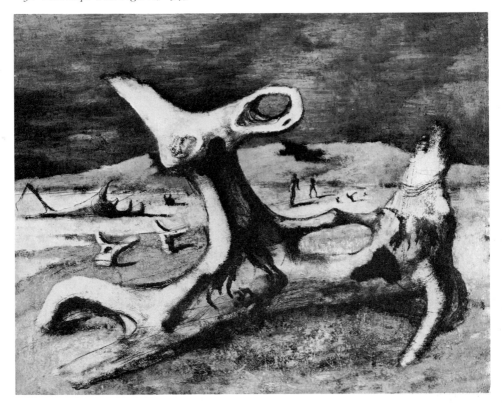

Pub Kitchen ~ Russell Drysdale

37 Mrs Gulotti,
Country Pub Kitchen,
1944

38 Woman and
Man Seated, 1944

Ill. 37 familiar with disaster; their toughness is not bravado. And tough they are. Mrs Gulotti, cook at the Commercial Hotel, Wentworth, is lighting her cigarette with a coal from the stove; Drysdale recalls that a few coals fell to the floor and she put them out with her bare foot.

Drysdale, however, does not see it all in terms of heroism and strength. There is plenty of evidence of human folly. A lot of the desolation was due not only to the fact that there had been less than three inches of rain in each of the last two years, but to the destructive stupidity of growing wheat in this country, not to mention the importation of the rabbit, and the further overstocking of pastoral country and eating out of young growth. But patience also implies the rhythm of hope. As Newman wrote in the first of the articles: 'Worse than the skeletons of animals and trees are the skeletons of homes. There

60

has not been any mass exodus even from the worst areas. To suggest it would be to create an entirely misleading picture. But here and there gaunt houses appear with empty black sockets where the windows were, doors flapping on rusted hinges, the spidery skeletons of windmills from which the iron wind vanes have blown or rusted away.

'Mercifully often, the nightmare vanishes with the night. In the morning the air is cool and sweet, the sky clear. It is then you understand why men come to the far outback – and stay. The refrain is always the same as they point to the scorched earth: "I have seen it waist-high with grass, and I will see it again." '

The grass may come again, but the trees will not. Newman pointed out the almost entire absence of young trees, while he and Drysdale could see, in uncleared areas across the river, how

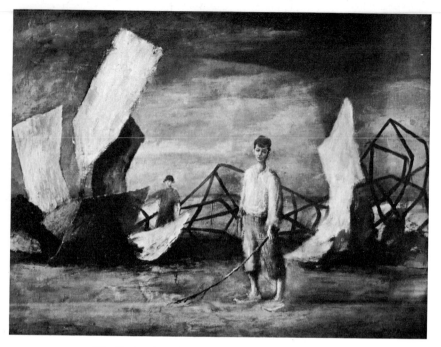

39 The Broken Windmill, 1945

40 The Rabbiters, 1947

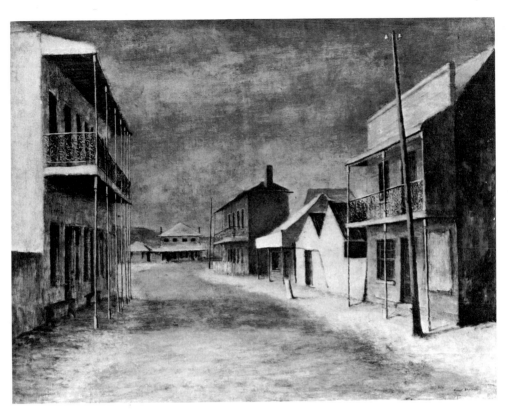

41 *Sofala, 1947*

the tough old mallee scrub was still holding out, clamping the topsoil to the subsoil. Knowledge such as this purges the false emotion that leads to enervating sentimentality; Drysdale's drawings are full of human sympathy, but they are sinewy and honest. They are also crammed full of visual ideas, storehouses for paintings, despite the skeletal simplicity of many of them.

The erosion of comforts and graces, the stripping away of the outward forms of beauty, brought forth two main streams of development in the paintings that followed Drysdale's 1944 drought journey. On the one hand he experimented with pure form and the symbolic qualities of lifeless objects, roots, tree trunks, corrugated iron, the framework of abandoned houses.

63

In another group of paintings he tackled, in a more realistic way, places and people commonly thought to be ugly, if they had ever been thought of at all as subjects for painting. Thus he developed simultaneously as a painter with the abstract qualities of form and colour and as a humanist extending the boundaries of humanism. Later, in his finest work, the two streams join; it is odd that they had their source in an appalling drought.

W. B. Yeats once remarked, rather patronizingly, of Walt Whitman that 'he lacked the vision of evil'. The same might be said, in much the same tone, of Russell Drysdale. In both cases it is the legacy of a deeply-felt democratic humanism; equally, the statement itself is a gross oversimplification. Whitman was well enough aware of the evil in himself, and he had more than his fair share of private and public horror, but he is the archetype of the democratic humanist who will not allow such knowledge to fault his faith in the positive and enduring

42 *Composition*, c. *1948*

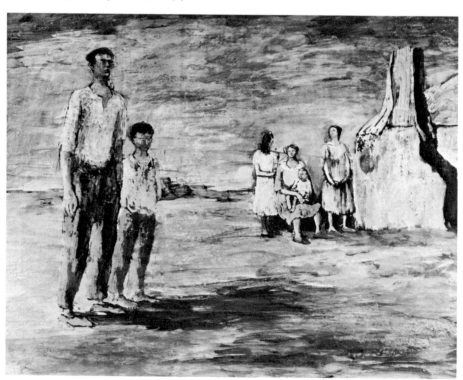

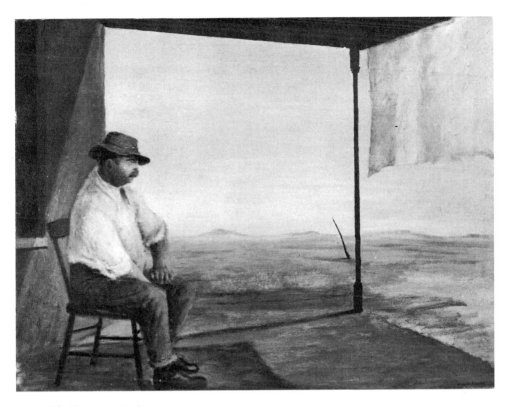

43 *The Prospector's Cottage*, c. *1949*

qualities of the human species. Australians are of this breed, with
a local twist towards the sardonic which, although it may
range towards an ultimate nihilism, remains good-natured
rather than malevolent. But the humanist Drysdale, the man
among men, the good bloke in a pub, is as devious a character
as old Walt, a self-searcher, afflicted by private blows of fate
that would have bent a less sturdy character, acquainted with
the disasters that nature and human folly can bring upon
decent, honourable people. Although evil is absent from
Drysdale's work, there is often a fearful presence of doom, like
the desert before a traveller. But Drysdale is of the Australian
breed who knows that he can make it to the next well if he
fills his waterbottle before he starts. Moreover, his humanism

does not extend to sympathy with the mug who does not fill his waterbottle. So great is the lure of evil in our doom-struck age that such a humanism may seem a little out of fashion, unlike the meretricious glamour of the monstrous world of Francis Bacon, were it not for the fact that in this sense the word humanism ('the quality of being human; devotion to human interests', O.E.D.) does not imply a crude optimism.

Whether or not it is because of some national temperament, a sense of sin, a vision of evil or even a genuine religious belief are hard to find amongst Australian artists (or writers). Albert Tucker, Arthur Boyd, perhaps Charles Blackman come to mind, and there is a hieratic splendour about the work of Leonard French. Nothing has demonstrated this more clearly than the foundation, some years ago, of the Blake Prize for religious painting, which practically every year has called forth a few good paintings, but scarcely ever one of genuine religious significance. One could predict that only one thing is certain about the Blake Prize, and that is that Russell Drysdale will never enter for it. But this does not mean that he lacks the reverence, the awe and the love that are basic to the Christian, and certain other religions; once again he resembles the archetypal Whitman in working these out in humanist terms. Nolan is the same, lyrical to Drysdale's epic; his paintings of murderous and murdered bushrangers, convicts, sacrificed soldiers and even Christ on the Cross are as far from sin and evil as a flower, and equally vulnerable. Again, the abstracts of John Olsen have the abandonment of Nolan, the affirmation of Drysdale, but no sense at all of a vision of evil.

Max Harris, in the most perceptive of all short accounts of Drysdale and his work (which appeared anonymously in *Nation*, 22 October 1960), pointed out the parallel between Drysdale and Martin Buber's humanist, that 'his stature both as a personality and an artist derives from an absolutely authentic relationship with his environment'. Drysdale's drought journey of 1944 did not shake this relationship, any more than did a later journey to investigate the plight of the aborigines,

66

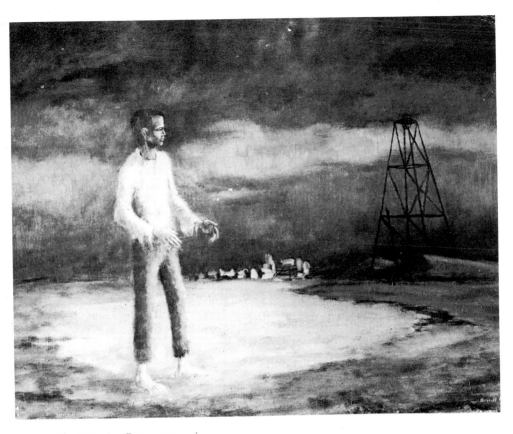

44 *The Listening Boy, 1949*

which will be discussed later. It does need stressing, however, that the confidence of this link between artist and man, man and environment, is not based on sentimentality or easy optimism, nor yet upon the heavy-handed pragmatism of the people whose survival in certain environments compels Drysdale's admiration. The paintings of the five years 1945–50 are often of subjects thought at the time to be shockingly harsh and ugly. The painter simply took them for what they were, having the forgiving eye of the genius who is neither evangelical nor haunted by original sin, however familiar he may be with mortal sinners.

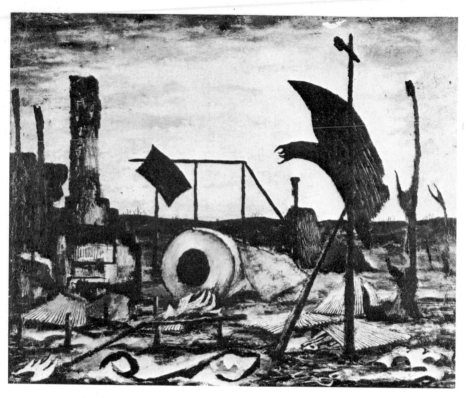

45 *Bush Fire, 1944*

The most striking feature of these paintings, compared with
Drysdale's earlier work such as *Moody's Pub*, is the simplification
of colour and the reduction to essentials of form. The favourite
and dominant browns and reds take over sky and earth,
streets grow emptier, figures more monumental, space rules
the landscape. The process can be seen even by comparing two
paintings as close in time and subject as *Bush Fire* (1944) and
Deserted Out-Station (1945), where the frame of the house, the
flapping pieces of corrugated iron and the dead trees become
part of a general process rather than a particular event. Drysdale
had painted strangely deserted country towns as early as 1943
(*Home Town*), but the conception and the execution are both

Ill. 15

Ill. 45
Ill. 46

Ill. 26

68

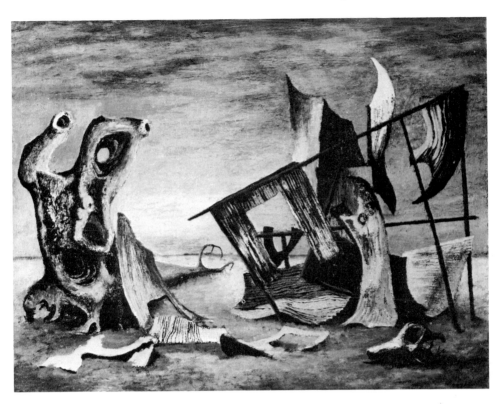

46 Deserted Out-Station, 1945

clarified and more confident by *West Wyalong* (1949). Though he continues to paint tall, thin figures when it suits his composition, and elegant, slender gumtrees, alive or dead, his figures are more solidly planted on the ground, and richer in their physical presence, with a wonderfully acute observation behind them. *The Drover's Wife* (1945), *The Countrywoman* (1946), and *Woman in a Landscape* (1948) are the finest examples of an extraordinarily difficult subject, one unattempted before in Australian, or for that matter, in any other country's painting. It is no use hunting for influences; these canvases of Drysdale's give one the authentic excitement of a new discovery that was so well described by Thomas Warton in the eighteenth century,

Ill. 52

Ills. 47, 48
Ill. 51

writing his *Observations on the Faerie Queene of Spenser*. 'We feel a sort of malicious triumph in detecting the latent and obscure sources from which an original author has drawn some celebrated description: yet this, it must be granted, soon gives way to the rapture that naturally results from contemplating the chymical energy of true genius.' (p. 75, 1807 ed.) Thus, although no painter had tackled the subject of women in the outback, there were literary examples, especially in the work of Henry Lawson. As has already been mentioned, Bernard Smith drew the parallel between Drysdale and Lawson. How-ever, a comparison between Lawson's story *The Drover's Wife* and Drysdale's painting of the same title shows 'the chymical energy' of the artist's genius. Lawson in this and several other stories had seen the poignant contrast between the fertile and tender womanly qualities and emotions and the harsh, thin, lonely nature of life in the outback. But Lawson, neurotic and desperately self-pitying, saw it in terms of a bitter drama, of an anxious woman, fierce in her frailty, battling with a snake or struggling to keep her geraniums watered. Earlier than Lawson there were writers like George Essex Evans (1863–1909) who wrote simple and sentimental ballads like 'The Women of the West':

Ill. 47

> In the slab-built, zinc-roofed homestead of some lately-
> taken run,
> In the tent beside the bankment of a railway just begun,
> In the huts on new selections, in the camps of men's unrest,
> On the frontiers of the Nation, live the Women of the West.
>
> The red sun robs their beauty, and, in weariness and pain,
> The slow years steal the nameless grace that never comes
> again;
> And there are hours men cannot soothe, and words men
> cannot say –
> The nearest woman's face may be a hundred miles away.

Yet, as another observer around the turn of the century,

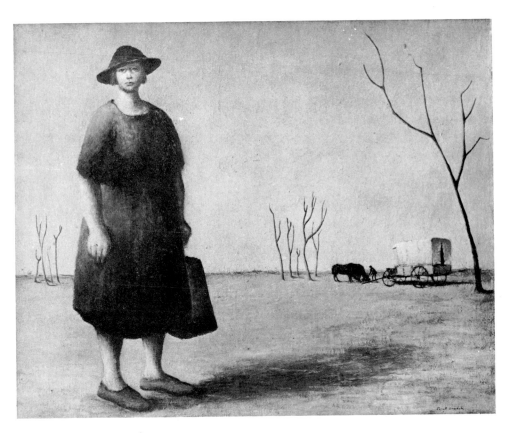

47 *The Drover's Wife, 1945*

Francis Adams, noted, it was the women who were responsible
for what culture and civilization there was in the outback.

 Drysdale saw it all, and recorded it with an honesty un-
attempted by the writers, who wanted to stir sympathy or
indignation. *The Countrywoman*, with the stiff delicacy of her *Ill. 48*
dress and flowered hat, keeps her grace and her femininity as
well as her standards; *The Drover's Wife* has lost her grace, but *Ill. 47*
certainly kept her decent, womanly standards; the woman of
Woman in a Landscape has little left at all except the strength of *Ill. 51*
her sex. Technically, Drysdale has subordinated everything to
the figure; her landscape, the details of her life, even the colour,

are dominated by her. What Berenson called 'small episodes' are ruthlessly eliminated. Although one has to look to literature for any parallels to these paintings, they are not in any sense literary, nor do they ramify into myth; in some respects, however, as Robert Hughes has pointed out in his *The Art of Australia*, 'there is neither "background" nor "foreground": the landscape and the figure *are* the myth.'

The 'truth' of these paintings is based on this unity that creates a myth while illuminating a reality, so that simple objects have further meaning as well as physical presence. Renoir once described the difficulties involved in achieving such a unity: 'How difficult it is to find the exact stage at which a painting should stop in its imitation of nature. What is necessary is that you get the very "feel" of the subject. . . . Granted that our craft is difficult, complicated; I understand the soul-searchings. But all the same, a little simplicity, a little candour, is necessary. As for me, I just struggle with my figures until they are a harmonious unity with their landscape background.' (*Renoir*, Walter Pach, p. 29.) Drysdale had the necessary simplicity and candour to extract this unity of truth, but at the time there were many who could not see it as truth at all.

A minor art battle, fought with all the clubs and stones of enraged philistinism, broke out over the inoffensive head of *Ill. 51* *Woman in a Landscape*, when in 1949 it was awarded the Melrose Prize in Adelaide and then bought by the National Gallery of South Australia. It had hung quite peacefully in Sydney in the Macquarie Galleries until Louis McCubbin, Director of the National Gallery of S.A., urged Drysdale to enter it for the Melrose Prize, which it won on 12 May, the judges being Hans Heysen, Professor Joseph Burke and Louis McCubbin. Burke said prophetically: 'It will not be popular. It may shock some people because it is not a pretty picture. But Art should be criticism of life and not a sugary imitation of it.' Two days later the letters started to pour into the morning paper, *The Advertiser*, and the evening paper, *The News*. The first one published warned of dire consequences: 'Unfortunately for the

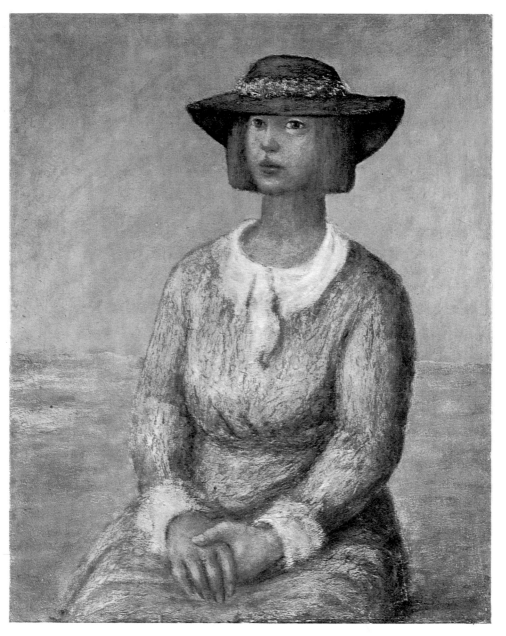

48 *The Countrywoman, 1946*

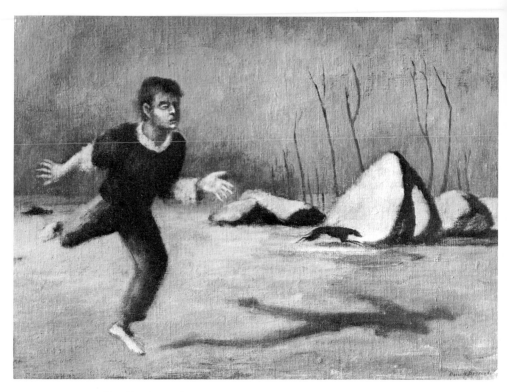

49 *Boy Racing with a Dog, 1949*

Commonwealth it will be necessary to prevent this picture appearing in England and Europe, where the effect would certainly defeat the immigration policy, as any decent person would abhor the idea of his wife or mother appearing like the picture in a few years after arrival in this country.' On 17 May a lady visiting Adelaide from a station in the Northern Territory wrote that: 'No outback Australian woman of white blood would be found, except perhaps in the most remote areas of our country, with such hideous proportions and apparel as the artist portrays. Having lived and imbued myself in the outback life of Central Australian pastoral activity for 17 years, I can honestly say that I have never seen a white woman constructed and clad in the manner Russell Drysdale has shown.' A con-

gregational minister did not lack confidence: 'An expression of gross ignorance of the outback. The painter cannot be spoken of as an artist, because the canvas is not artistic.' This aroused Kym Bonython (who now owns the best collection of contemporary Australian art in the country, as well as running the Bonython Gallery, but who then lived in the country breeding stud cattle) to reply that it was a fine and forceful study, of which the ugliness was irrelevant. As for ignorance, it was actually 'based on a living person who today dwells in the house so truthfully depicted near an old, deserted mining town some 200 miles west of Sydney'. In *The News* the paper's art critic, Ivor Francis, had praised Drysdale's drawing and colour, but had given judgement that there was 'no significant relationship between a vast barrenness of landscape and the well-fed, podgy body of the stupid, aimless, lumbering female, unless we admit

50 *Joe Resting, 1945*

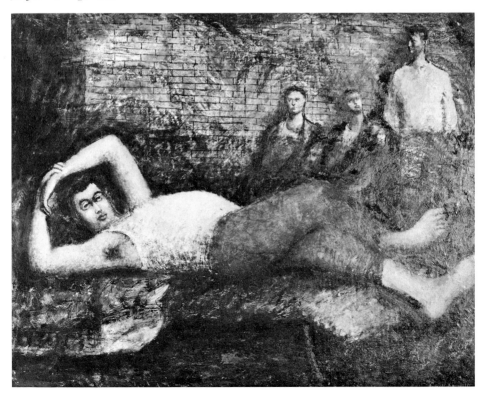

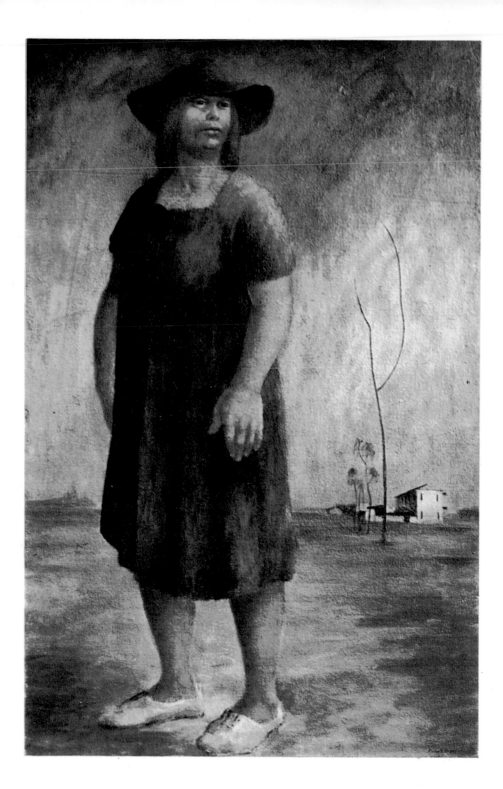

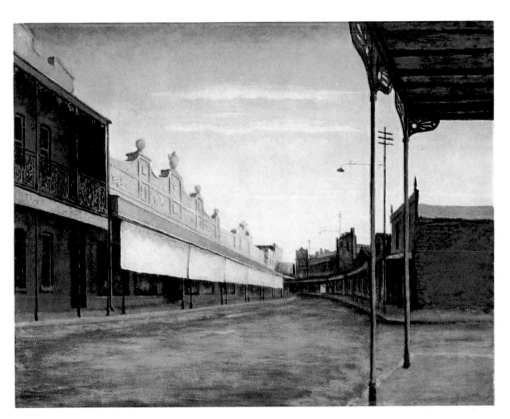

52 *West Wyalong, 1949*

their mutual vacuousness'. The next day Sidney Downer
protested, admiring 'its obvious qualities of power, vitality,
colour and drawing'. He continued that he had recently visited
the Mallee area and found 'the same faded dreadful air of
inevitability and destruction pervading everyone and every-
thing that man has touched there'. Two women, Mary Harris
and Ruby Henty, also defended the painting eloquently in *The
Advertiser* against those who thought it an 'insult to the women
of the outback', or, alternatively, 'a slum type, not representa-
tive of the outback at all'. But perhaps the best letter of all came
from Mrs A.F. Lord, of Blinman, in the Flinders Ranges far

77

53 *Country Child, 1950*

54 *Joe, 1950*

north of Adelaide. 'I sacrifice myself on the altar of Art. I am a "Drysdale". I can account for the appearance of my sister on canvas. Her somewhat ungainly stance is probably caused by worn sandshoes and a couple of obstinate bunions on her right big toe; "the simple, unbroken line" of her figure, to the fact that she had not taken her "Venus Form" tablets lately, and that just when the artist was around, she left off her corsets. Her lank locks? Well, her perm. had only just grown out. The point is that Drysdale caught her off guard. To all the hunters with palette and brush I say, "Sneak up on them; catch them on the hop and you'll get a dozen Drysdales a week." '

Such a fracas would not be worth recording were it not for the light it throws on the relation between an original artist and his subject matter. Here was Drysdale, who has often been called the most distinctively Australian of modern painters,

78

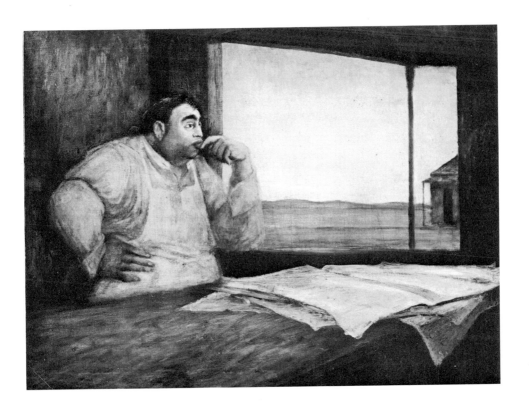

being told by a large section of the community that he could not tell the truth. His own comment was a baffled 'But it was only Big Edna, that's all'. Just as he had accepted her, so she had accepted her environment, so that instead of the nervy, anxious women of Lawson's stories, she (with her Drysdale companions) stands strong and patient, rebuffing loneliness like the heat or the duststorms.

The same qualities are present in two portraits of 1950, *Maria* and *Joe*, where the familiar solid bodies are in this case surmounted by Greek heads with the impassivity of ikons. Watching the street of the country town from the verandah or the window of the café, Maria and Joe have no restlessness, no compulsion to move towards the hypnotically evoked distance. Like the painter himself, they are devoid of prejudice, waiting for someone to turn up, who will undoubtedly want

Ills. 54, 55

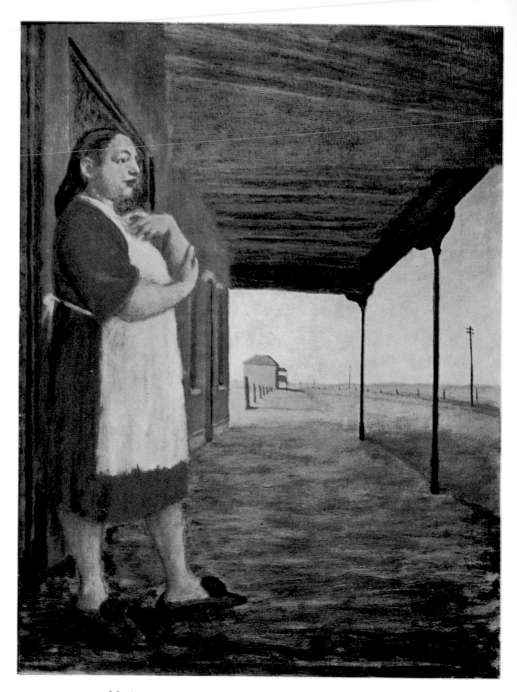

55 *Maria, 1950*

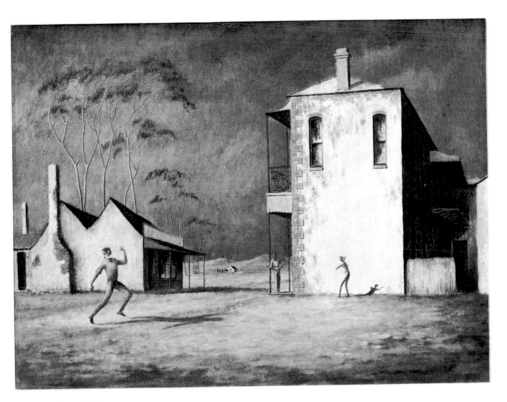

56 *The Cricketers, 1948*

steak and eggs. Whatever the loneliness and desolation of the place, there is a basic need in the human being for steak and eggs, and Maria and Joe are quite confident that they can supply that need.

In the richening luminosity of his paint, and the disposition of his huge, heroic figures, Drysdale was adapting for new purposes some of the qualities of his favourite Venetian painters, although on the whole he preferred to evoke repose rather than energy. With this exception, one can see the link by comparing Berenson's comment on Tintoretto: 'The figures, though colossal, are so energetic and so easy in movement, and the effects of perspective and of light and atmosphere are so on a level with the gigantic figures, that the eye at once adapts itself

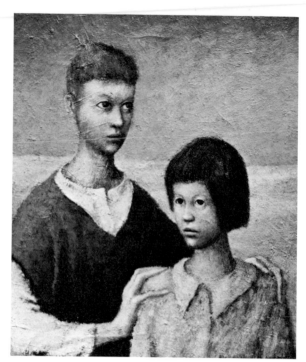

to the scale, and you feel as if you partook of the strength and health of heroes.' (*Italian Painters of the Renaissance*, p. 26.) Times being what they are, no one has ever offered Drysdale the walls of a palace, a church or an academy, but one feels sure he would welcome the large scale; indeed, Sir Daryl Lindsay and George Bell both recall that one of his earliest works was a mural on the walls of Bell's school in Melbourne, subsequently demolished.

One interesting painting of this period, in which, for a change, a line of swift and expectant energy runs through a typically static scene of houses and landscape, is the fine piece *Ill. 56* of composition *The Cricketers*. There are several amusing instances in Drysdale's career of art coming in contact with a very unaesthetic life. *The Cricketers* was commissioned for the rather eccentric Sir Walter Hutchinson's Gallery of British Sports and Pastimes in London, although 'commissioned' is

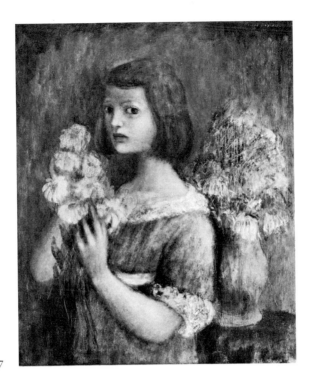

58
Portrait of
Lynne, 1947

somewhat too definite a word, since Drysdale merely promised that if he should paint something suitable he would sent it to Hutchinson. This painting did seem suitable, and he sent it off. Hutchinson, however, was expecting a cosy scene of little white cricketers in the middle of an impeccable green oval, and Drysdale's bush hit-up was altogether too crude for his taste. He sent the picture off for auction, where by great good fortune it was secured by an Australian, William Ritchie, then on a visit to London.

Drysdale has great gifts as a portraitist, but he has seldom painted direct from the life and he has never accepted a commission. His early training with George Bell taught him to use both his memory and a generalizing imagination, so that he prefers to bring an image home to his studio, where he can paint what he cannot see. (He well remembers George Bell finding him, as a student, drawing a model; Bell told him to

83

stop drawing what he could see, and draw, from other angles of the room, those portions of her body that he could not see.) So the drover's wife, Big Edna, Maria and Joe and the beauti-

Ill. 57 fully austere little *Two Children* are not only recognizable portraits of individuals but also evocations of character in circumstance, unmistakable in themselves but also types. In this Drysdale is quite different from his great contemporary the portrait painter William Dobell, who in his best work uses mannerism to accentuate his own conception of individuality, seizing on different elements of that individuality and develop-

Ill. 61 ing them with a rococo flourish. Drysdale's portrait of Donald Friend is a rare example of this sort of treatment. More typical

Ills. 58, 60 are *Portrait of Lynne* and the exquisite *Margaret Olley*. Several critics have compared Dobell's portrait of Margaret Olley, which won the Archibald Prize of 1948, with Drysdale's of the

59 *The Councillor's House, 1948*

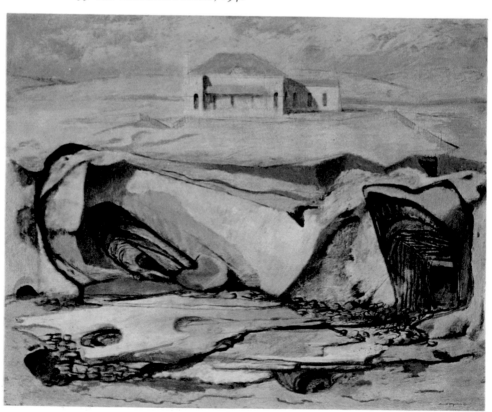

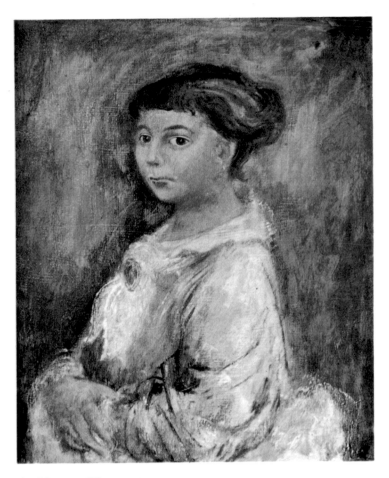

60 *Margaret Olley, 1948*

same year, and noted the extraordinary differences which two usually acutely observant painters can find in the same person. But in Dobell's case one feels the artist imposing his vision, not to strike down to a basic truth, but to use the subject as an excuse for a certain sort of painting. Dobell's confection has a race-day vulgarity, dressed-up to kill and hoping for photographers and winners. Although the superb bravura of the painting carries it off, there is a suspicion that the painting as a whole lacks conviction. Drysdale's portrait suggests why.

85

Despite the engaging quality of the face, the alert eyes and the lips that look as if they can scarcely be kept closed, there is a fleeting modesty about the subject reflected in the line of the hair moving away into the background, the softness of the dress and the tenderness of the hand, and especially in the restrained lightness of the paint that suggests a subtle and elusive character that has more integrity than the brassy bounce of Dobell's subject. Drysdale's painting owes something to the Renoir of *Gabrielle in a Red Blouse* (despite the different handling of the surface of the paint), but only in the sense that at peak moments every new painter rides forward on the work of great

Ill. 60 kindred spirits in the past. *Margaret Olley* is a little masterpiece.

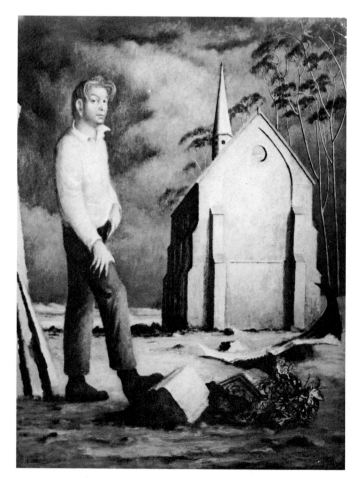

61
Picture of
Donald Friend,
1948

The People in the Landscape

After 1950 there are new developments in Drysdale's technique and imagery, culminating in the decisive paintings of 1953 which lead forward clearly to much of his latest work. Once again, a break in his life accompanied a development in his art. When Sir Kenneth Clark visited Sydney in 1949 he was particularly impressed by Drysdale's work (he later bought a notable example, *The Councillor's House*). He urged Drysdale *Ill. 59* to exhibit in London, and this was followed by an invitation from the Leicester Galleries where Drysdale exhibited in late 1950, having travelled to London with his wife and children. The show was very successful both financially and critically, although it is amusing to note that paintings like *Emus in a* *Ill. 62* *Landscape*, which led a critic like Robert Melville to deprecate Drysdale as a latter-day surrealist, are in fact constructed of real objects in a real place, familiar to an Australian but fantastic to an English eye. (Not that many Australians would have seen such a sight, but the ingredients would be familiar.) The national quality of the paintings, the result, as we have seen, of meditated experience and not of any foolish jingoism, impressed many critics and buyers. Here was something universal in significance, but unmistakably local in origin. Sir Philip Dunn, who bought *George Ross of Mullengandra*, told *Ill. 63* Oliver Brown of the Leicester Galleries that he was walking down Leicester Square and saw this painting in the window of the Leicester Galleries, standing out utterly clear from the mass of London humanity around it, and in colour equally clearly from another world.

The world of art, however, is not the world of life. Drysdale has a story about this painting which not only illuminates that contrast but also the utterly unselfconscious approach to art in

87

such people, whom Drysdale likes so much to paint because they are so honestly themselves. George Ross owned the little hotel north of Albury, on the main highway, at Mullengandra. After Drysdale's return from London he happened to be travelling by car down to Albury, and he took along a photograph of the painting to give George Ross. Handing it over, he jokingly apologized for leaving out the elm trees which grew in front of the hotel, explaining that he wanted to concentrate in the painting on the figure of George Ross and the hotel building behind him. 'Oh that's all right about the elms, Tassy,' said Ross. 'They're buggers to sucker, anyway.'

Ills. 65, 66 Some of the best paintings in the 1950 London exhibition were of children (such as *Children Dancing, No. 2*, and *Children in a Bath*). Drysdale has always been especially successful, both in drawings and paintings, with children and with that classic

62 *Emus in a Landscape, 1950*

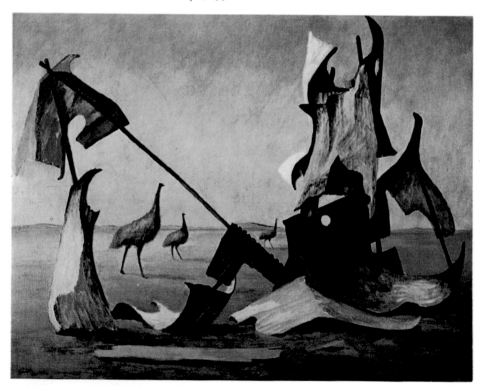

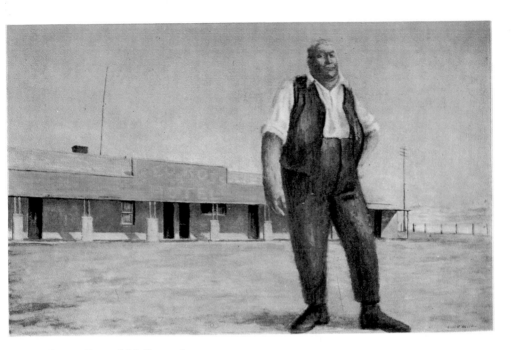

63 George Ross of Mullengandra, 1950

subject, the mother and child. The line runs clear from *Two Children*, a painting of 1941 to *Bush Children*, a drawing of 1961. *Ill. 132* Perhaps it is the strange combination of fragility and toughness in children that appeals to him; he certainly conveys it. Also their ability to improvise games out of the simplest materials, or none at all, reflects the same quality of adaptation to environment that Drysdale admires, with their imagination providing an extra stimulus, so that his children are often dancing or playing where his grown-ups are serious and stock-still. *Children* *Ill. 66* *in a Bath* is a beautiful example, with its transposed imagery that seems fantastic but is in fact logical, as children are, with the bath serving as the boat of the desert, the old curtain as a sail, with broken posts and sheets of corrugated iron hanging around like masts and sails. The London critic may have seen surrealistic fantasies in this little picture, but it is in fact perfectly true to life; one recalls the Alice Springs regatta, where the

89

inhabitants turn out once a year to have rowing races and water-skiing events in the dry sandy bed of the Todd River. The sight of eight husky men running along with their legs through the bottom of a boat they are holding up might well seem not only surrealistic but plain daft to a Londoner.

Drysdale returned to Sydney in 1951, and moved house the next year from Vaucluse to Darling Point. Towards the end of 1951 he travelled up to the Pioneer Sugar Mills, of which he had been appointed a director in 1947, and then went on to the wild country of the Cape York Peninsula. The most important result of this trip was the intense interest it aroused in Drysdale in the aborigines, both as a people and as a subject for painting. As with his earlier discoveries with landscape, the new imagery grew organically from the roots of his own

64 *Mother and Son, North Queensland*, c. 1950

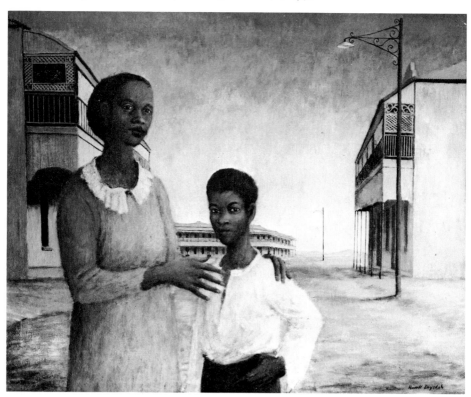

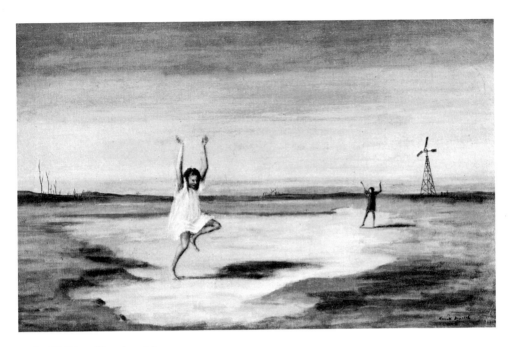

65 *Children Dancing, No. 2, 1950*

experience, and was not grafted on to his artistic development
as a result of a deliberate search for new material. Drysdale has
never searched for new 'copy', in the journalistic sense, though
he has always travelled with his eyes open. What drew him to
the aborigines, apart from their dignity and their human
qualities, was that they represented an earlier, more complete
stage of that integration between man and environment that
he had always respected and painted so successfully. At the
same time, neither as an artist nor as a man was Drysdale likely
to fall into the old trap of depicting the aborigine as a noble
savage, nor into the newer trap of sentimentalizing his degra-
dation. Early Australian painters such as George French Angas,
S. T. Gill and Robert Dowling had made some effort to paint
the aborigines, Angas for scientific reasons and Dowling to
capture the historic tragedy of the extinction of the Tasmanian
aborigines. Only Gill took them for granted as part of the

landscape, and as the sometime enemy, sometime friend of the white invader; in this, as in so much else, Gill was a pioneer of distinctively Australian art.

For almost a hundred years after these painters, the aborigines were either forgotten or ignored, save for their exploitation on Christmas cards or souvenirs, hurling boomerangs or throwing spears, a very Australian sight that perhaps two per cent of the Australian population has ever seen. Then, oddly enough in the same year of 1951, Drysdale went to Cape York and Arthur Boyd went to the Northern Territory, and out of these two journeys came the first paintings of aboriginals to have any universal significance as art. Arthur Boyd went in search of landscapes to paint, and came back with an allegorical series, in which black, white and half-caste are mixed in the rituals of

66 *Children in a Bath, 1950*

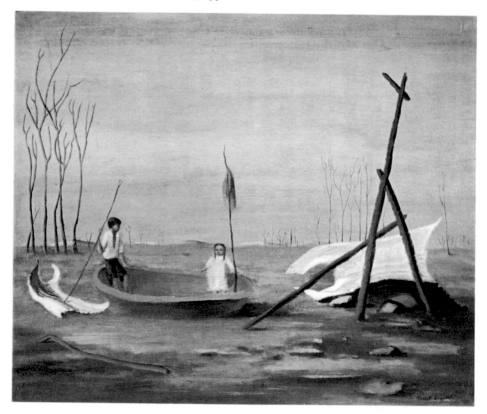

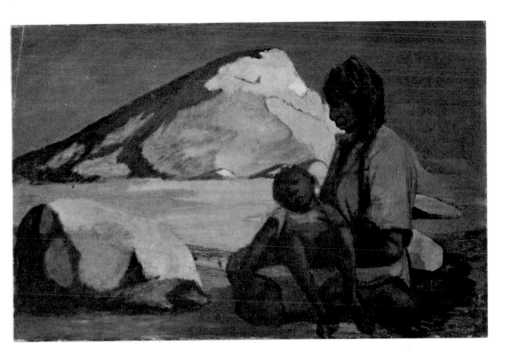

67 *Mount White, 1953*

love, marriage and death. Boyd was distressed by both the
personal and the social relationship. In a B.B.C. broadcast he
has said: 'They're forced into this position, and it just has a
very serious effect on you when you're not used to it. You
don't know about it and you suddenly come against it, after
imagining that they're noble savage types living in the bush.
In their rites and in their dance and things there's a sort of
rhythm, but there isn't any fire in the same way as the African.
It was an Australian subject, I suppose, because they are as far
as I know the only native race, aboriginal race, that have this
tremendous softness and passivity.' (*South Light*, broadcast on
the B.B.C. Third Programme, 24 July 1963.)

Drysdale's approach to the aborigines is quite different,
although that 'softness and passivity' is noticeable in many of
his paintings of them. However, with his country background,

93

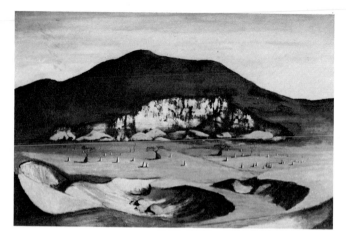

68
The Broken Mountain,
1950

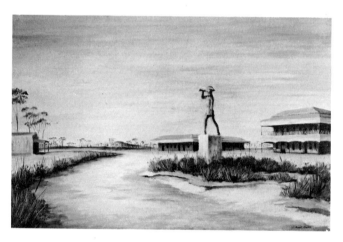

69
War Memorial, 1950

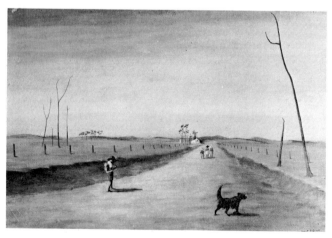

70
Going to School, 1950

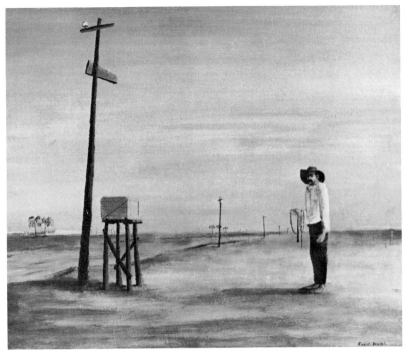

71 *Greenhide Jack at the Mailbox, 1950*

72 *Anthills on Rocky Plain, 1950*

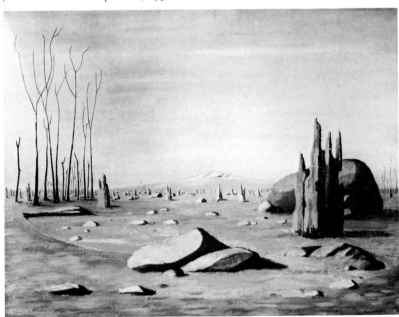

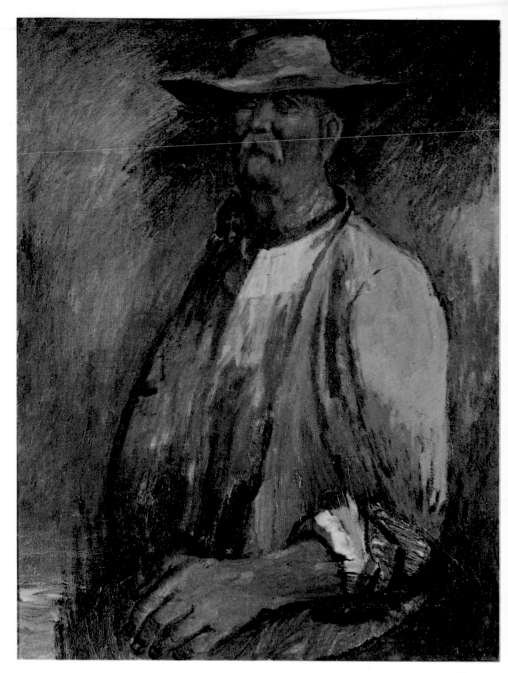

73 *Old Larsen, 1953*

74 *Sketch of Aborigines, 1950s*

he also saw many of the men as the tough and wiry station
hands and stockmen without which most of the stations in the
north would collapse, not only active but engaged in an activity
that is not tragic. The women, especially the mothers, and the
children, or those still remote from the white man, are quite
different, rounded out, relaxed, complete in themselves.

 Several of the 1953 paintings of aboriginals take a stage
further earlier images of landscape and country towns. If the
figures were removed from the 1953 *Mullaloonah Tank*, a *Ill. 78*
variant of the austere 1952 *Desert Landscape* would remain, a *Ill. 76*
moulded, cratered landscape quite different from the flat
horizontals of earlier pictures again, like *The Drover's Wife*. *Ill. 47*

Ill. 77 Similarly the town in *Shopping Day* (1953) could be West
Ill. 26 Wyalong or the street and houses of *Home Town*, but now in
the foreground loom four black figures, bare feet below, in-
congruous hats above, all ironically saluted by the frozen bugle
blast of the white soldier on the war memorial. The figures
themselves stand in stiff postures, waiting, as if they had been
told to watch for the dickey-bird in an old photograph. In
Ill. 79 *Station Blacks, Cape York* and the two paintings just mentioned
this stiffness partly reflects the arrested development of the
aborigines, bare feet still on the familiar hot earth, bodies in
alien clothes, minds expecting direction, and it partly continues,
in purely artistic terms, Drysdale's earliest strictness of form.
Ill. 8 But whereas in the 1938 *The Rabbiter and his Family* the figures
are stiffly posed for mannerist reasons, in the 1953 paintings
there is an authentic pathos about the stiffness; the aboriginals
are not posed by Drysdale, they have adopted these attitudes

75
Aboriginal Woman,
1950s

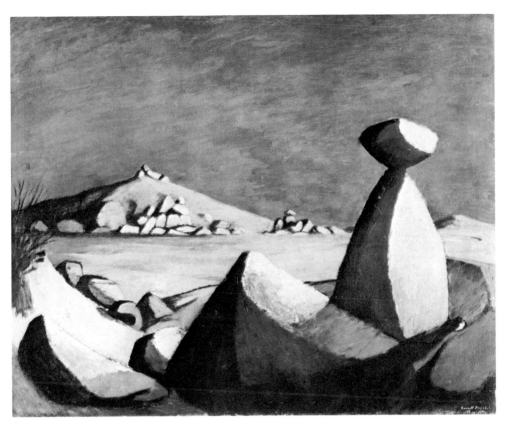

76 *Desert Landscape, 1952*

themselves, instinctively in their situation. This naturalism
worries some critics, Bernard Smith for instance, who writes:
'He adopted a highly realistic treatment both of pose and
expression in the rendering of his aborigines that is at times out
of keeping with the abstracted landscapes into which they are
set. In some ways these paintings are a compromise not
altogether satisfactory between the realism of the 1941 Albury
paintings and the classical landscapes of 1949.' (*Australian
Painting*, p. 251.) This is an odd criticism, for looking at these
pictures it seems clear enough that the tonal simplicities of the
aboriginals are in perfect keeping with those of the landscapes,

99

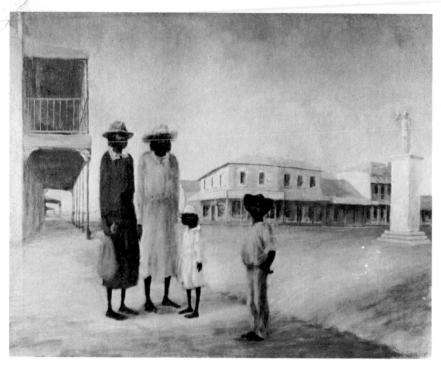

77 *Shopping Day, 1953*

78 *Mullaloonah Tank, 1953*

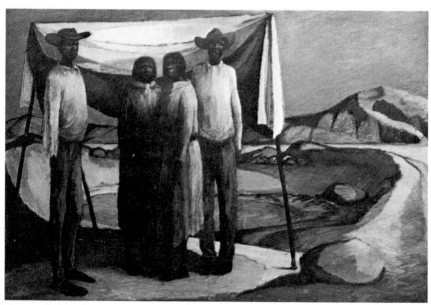

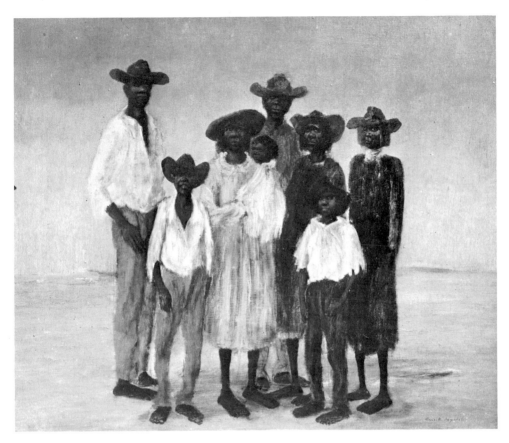

79 *Station Blacks, Cape York*, 1953

just as the thin poles of their legs are also those of the verandah posts or the supports for the canvas shelter against the sun, and the curves of their broad-brimmed hats are those of the scooped boulders and cratered hollows. The paintings are classic in their balance and calm, however disturbing they are by implication; Drysdale, during his stay in Paris, must have closely observed the Claudes and Poussins in the Louvre.

The simplest, most concentrated and most moving painting of this series is the monumental *Mount White*, and it is note- *Ill. 67* worthy that this is of a mother and child. The modesty of

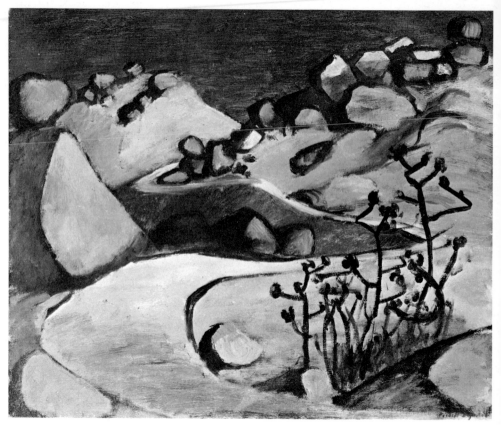

80 *Road to the Black Mountains, 1952*

colour, the economy of the superimposed triangles of form
and the resignation of the woman sitting on her ankles would
give this painting the quality of muted tragedy were it not for
the figure of the child, sick, dying or merely sleepy, which,
without any spurious appeal to the emotions, intensifies the
whole mood of the painting. The means are the uncannily
simple ones of completely confident draughtsmanship, the
child's head leading up to the mountain, his arm leading down
from the mother, but neither with any of the strength of those
two equally solid figures, while the helpless legs hang outwards.
It is a composition Drysdale has returned to, without in any

sense repeating himself, in one of his finest paintings (*Mother and Child*, 1963). *Ill. 111*

Another major achievement of 1953 was the imposing but endearing portrait *Old Larsen*, which foreshadows later work *Ill. 73* such as *Happy Jack* (1961). These are painted *con amore* by the Drysdale who is accepted by such people as a man, if not as an artist. He paints them with the simplicity and the humour they deserve.

The best way of illuminating Drysdale's feeling for such people and for the landscape they inhabit is to quote his own words on the subject. The following passage, written as an Introduction to a book of photographs of Central Australia by Allen David (*Form Colour Grandeur*, Grayflower Publications, Melbourne, 1962), shows that Drysdale, if he had not given all his energies to art, could also have worked with words. (Part of this Introduction is expanded from his Introduction to the

81 *The Camp, 1953*

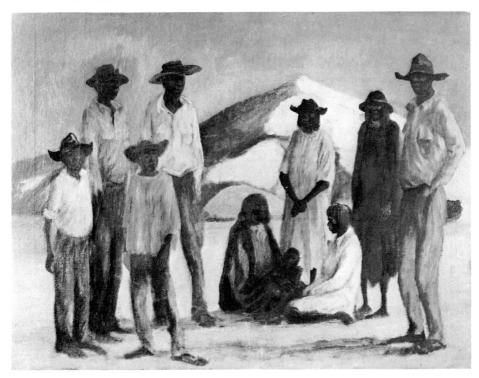

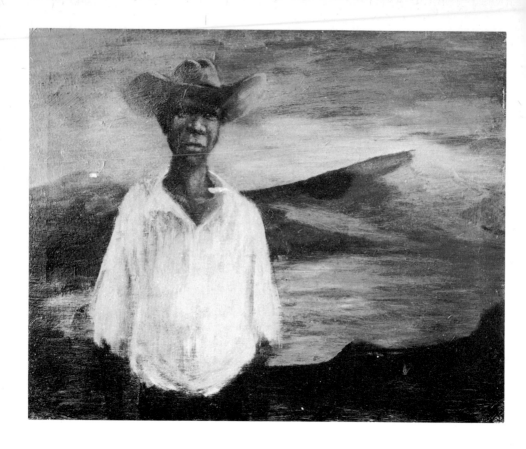

Catalogue of his 1958 exhibition of paintings of Northern
Australia at the Leicester Galleries.)

'I remember waking one morning to find a bird, head to
side and eye intent, regarding me so closely from so short a
distance that I could not bring my eyes to focus properly. In
that bright morning it appeared to me the most monstrous
creature I had ever seen. To wake from dreamless sleep into a
dream world can be a disturbing experience. Reality blurs in
relation to a new and startling scale, and one sees through the
eye of an ant. The moment ended with a spread of wings. I was
no longer lost but lying in my swag looking at a magpie
settling on a log, and I rolled out of my blanket into the early
day.

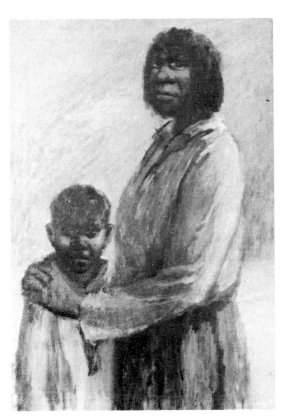

82
Young Man, 1953

83
Mother and Child,
1953

'To live for any length of time in the far regions of The
Centre, camped in a swag and removed from the compass of
society, needs a new adjustment. Incidents of a rapid adjustment
to a difference of scale as the small affair of the magpie shows,
become a familiar part of daily life. It is a life that demands a
different set of values, a heightened perception which in turn
develops a new awareness. What appear at first oddities become
almost commonplace through a new interpretation. For in-
stance, where the growth of zerophytic shrubs and trees gives
no height for birds to examine strangers in their territory, they
must perforce come to close quarters. Birds are always about
you and near you in a camp, and not distant in high branches
as they would be in a forest. It is one of the delights of these

lonely places to find so often that there is no loneliness. The constant and close company of birds in the central places of Australia is a charm and a reassurance to the gregarious nature of man. He soon becomes acquainted with the individuality of his companions in a way that he may not elsewhere. And he can come to recognize with satisfaction the peck order of a society which appears no more magnanimous than his own. In The Centre it is the birds who chiefly share the day with man. The marsupials are primarily nocturnal, coming from their daily resting places in the evening light, quietly grazing through the hours of darkness, and returning before the heat of day to some cool hiding place.

'There is still a great area of Central Australia that is untramelled land. Though subject to the mores of Commonwealth administration, and economies based largely on the cattle industry, there are great stretches free of man's settlement. The areas occupied by cattle stations are on so large a scale that impingement upon flora and fauna is not always noticeable. It is still largely a land of animal population. The imported breeds of domestic cattle share with the marsupials such a spread of ground that it soaks them into anonymity as a sponge sucks water. It is remarkable that so much inherent life, native or foreign, is unremarked, for the premises of their living borders on enormity. One can look across a wide landscape which seems utterly devoid of life, or travel long distances without seeing a creature on the land. Ten thousand head of cattle in ten thousand square miles become so many needles in a haystack. Reduce the scale drastically and there is life in plenty. Place a lamp amongst the Mitchell grass in camp at night and from its blonde growth will come a host of small creatures to throng about the light.

'It is difficult to describe a place so removed from the qualities and scope of urban living. There are clichés of generality – Red Sand and Spinifex – Dead Heart – but they no more come to terms with its reality than the mirage on the horizon. It has the form and shape of a frontier land, and it has the legends of

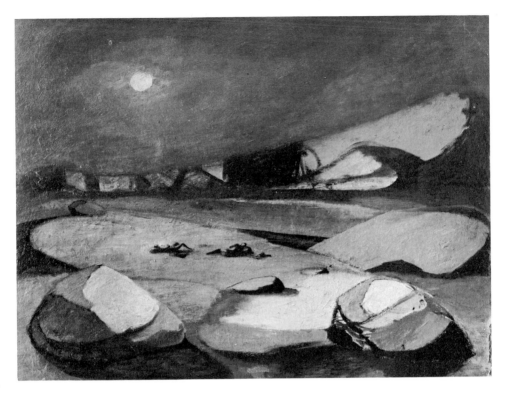

84 Full Moon, 1953

a frontier. The familiar tales of goldrush, pioneer epics and incredible journeys of exploration. From this background have grown the few centres of town life. But though transports and road trains roar day and night along the thousand miles of bitumen between the Alice and Darwin, the country to either side of the road has changed but little. McDouall Stuart and his men, who painfully blazed that trail a hundred years ago, would see small change in the growth about them. The nomadic aborigines have lost their close-knit tribal society. Employed as station hands, or gathered into settlements, they are rapidly losing the precepts of their lore. Only in the great wastes of the Central Western Desert are there small groups of nomadic hunters far removed from civilized habitation.

'The thin veins of modern progress traversing the land occupy little space. The rest is vast. Great plains and desiccated mountains. The all-pervading mulga, whose thrifty shade dissolves into visions of vulgar mementoes carved for city dwellers. Wildflowers after rain, mulla-mulla, parakeelya, and everlastings. Lancewood and bullwaddy, thrusting out like Rackham's childhood fantasies. Bulldust, heat, drought and mud-dried animals embedded in the stinking remnants of a waterhole. Rain like rods bursting into the dust, and soil-engorged water pelting down a gully. The myriad insects of the wet that propagate and die and plague the life of animal and man. Or the grandeur of the ranges suffused in the glow of evening light. The tremendous sweep of sky and plain and the brilliance of the stars at night. Ominous red skies of dust, or the incandescent blue of evening when a lonely tree stands sharp in the distance and a shout will carry for miles.

'All these things say something of it but not the whole. The paradox of such a wide land is that it is often glimpsed more sharply through small, pointed details within the whole. The unemotional meeting of mesolithic nomad and civilized man in the Great Victoria Desert may seem normal because the scale of time and environment is too large for wonder. To discover a man lost five years gone is an event of great emotion. To find a man from the period of the last Ice Age is too remote for joy or solicitude. Too difficult for immediate response, too damned odd anyway. So nobody remarks and the courtesy of a cigarette breaches a span of time beyond the reach of history. Curiously it is not the fact that you met him in the mirage, or of what he is that astounds you. It is that he should be there where no man should be and, not just within his forbidding landscape, but part of it. It is the little things, the piquancy of small images that let you see through his self-sufficient whole, to a new conception of the land in which he lives. His gesturing hands, anatomically yours, are comported in a different manner. The eloquence of agile fingers drawing in the dust, or feet that have never been encased in boots or shoes, horned

85–89
Pen sketches, 1950s

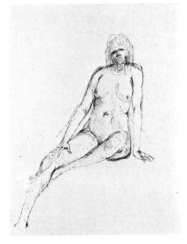

with heavy skin, pressed by hard and constant movement. Through them you glimpse another world. Hard, hot, and stony ground, of fingers skilled in the fashioning of implements and the skinning of game. As though they were interpreters, the land about takes on another meaning through their inflexions. The objectivity of description becomes subjective. The outward appearance, so suitable and adequate for explanation, is just not good enough. When you think that you have a good idea of the general look of it all, a small image of seamed and gesturing fingers or a magpie out of focus can slew you in your tracks.

'It is not the obvious, but the underlying incomprehensibility, the incongruity, the pervading enigma of a land, its people, flora and fauna virtually in a condition in which it evolved, that wrenches the mind into an awareness, take it or leave it, of an ancient world which brings excitement to the soul. A

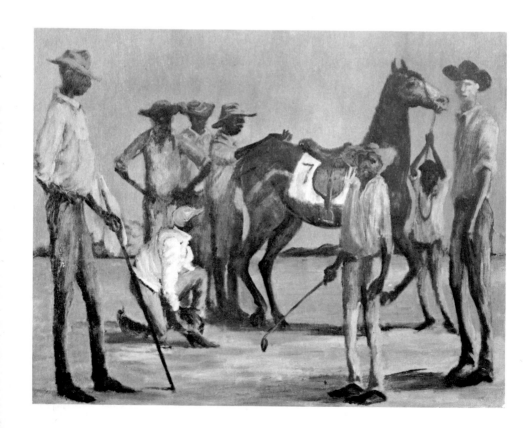

world where incongruity becomes the accepted commonplace, where the air echoes alike to the chant of the rainmaker and the drover's call for a beer. A world both sparse and plentiful, of loneliness and life, but a world that is strange, exciting and splendid.'

There are many keys here to the cast of mind and the processes of thought behind Drysdale's painting. There is the scientific interest and accuracy, the regard for the zoological or geological framework, intensified by his friendship with eminent scientists such as Professor A.J. Marshall, or Dr D.L. Serventy of the Wildlife Division of the Commonwealth Scientific and Industrial Research Organization. There is the artist's eye for detail, and the imaginative need to go deeper than details of behaviour to 'a new conception of the land' and its aboriginal inhabitants. There is also the artist's sense of form: 'The outward appearance, so suitable and adequate for

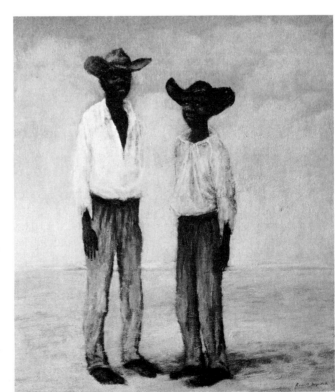

90
*Saddling up at
the Coen Races,
1953*

91
*Young Station
Boys, 1953*

explanation, is just not good enough.' There is also, perhaps most powerful of all emotionally, the joy in freedom and the acceptance of loneliness – 'the delights of these lonely places' – by the man who is forced by his genius to spend most of his life cooped up in a studio in the heart of a city. Finally, there is a sense of scale, a measuring of the wrongs of man against the savagery of nature, of the human rat-race against the birds of day and the animals of night.

Drysdale spent the years from 1952 to 1956 painting at his house in Darling Point. In 1952 he was invited to show at the Carnegie International as one of four Australian artists, and in 1953 he had a one-man show in Sydney. In 1954 he was chosen to exhibit at the Venice Biennale as one of three artists representing Australia.

In 1956 he spent six months travelling in Northern Australia, at first in a Dodge station wagon accompanied by his wife and son Tim; later, finding that the Dodge could not cope with the more difficult country, they transferred to a Landrover. At Darwin Bonny returned to Sydney and Drysdale and Tim completed the journey by themselves. Fortunately Drysdale kept a journal of the trip.

After travelling up to the sugar mills at Pioneer they went on to Townsville and then began the long haul westwards to Cloncurry and Mount Isa and the Northern Territory, 'a thousand miles away', in the words of the old song. West of Cloncurry imagination and reality began to mingle. 'I found myself looking at two mad mountains I've painted. It gave a dreamlike quality to the whole thing.' Going on, he searched for Cambrian strata, noted the wild squalor of the mining town pubs of Mount Isa, called on station people, met by the road drovers who had been in the saddle since December (it was then the end of July), heard stories of murders, was in raptures over the wildflowers. When they reached the Stuart highway they turned south for Alice Springs, a tourist route along the edge of the wilderness. The Barrow Creek publican said to them, having just fed eighty tourists on a bus tour to Darwin: 'God

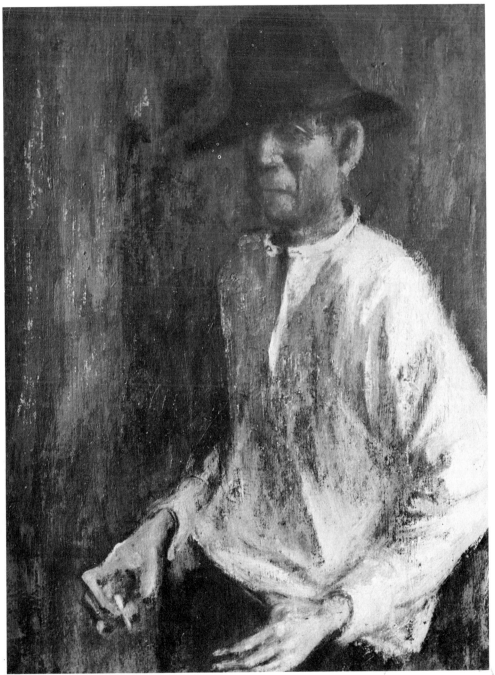

92 *Midnight Osborne, 1954*

knows they never spend anything – they leave their homes with a clean shirt and a fiver, and return home having changed neither.'

Drysdale is one of many who have noticed and been depressed by the strange habits of the human species, oddly clad examples of which will band together in busloads to roar shouting into the solitude of places a thousand miles from the nearest city, take a photograph and roar off again. At Standley Chasm, near Alice Springs, 'a wonderful, deep place echoing with birds became suddenly filled with shouting hulloes and voices anxiously screaming: "What exposure will I give it?" and "You stand over there, Mum, where I can get you in the picture." '

Later, bogged in the sand of the Finke River with their two-wheel drive vehicle, Drysdale was confirmed in his opinion

93 *Boy with Lizard, 1955*

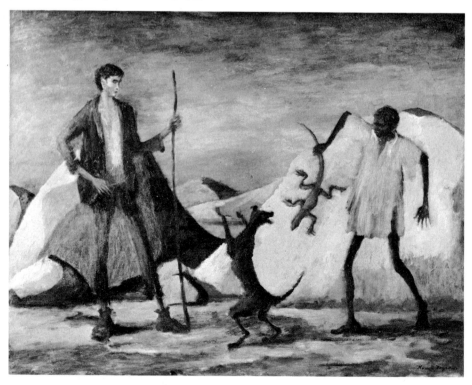

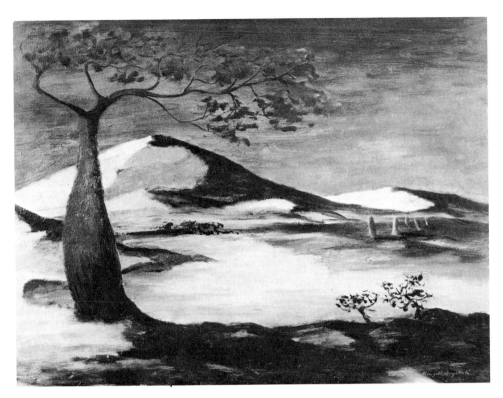

94 *Small Landscape, 1955*

that they would do much better with a four-wheel drive
Landrover, and he later managed to trade the Dodge in for a
Landrover at Alice Springs, in which they drove out to Ayers
Rock and Mount Olga. At night Bonny slept in the back and
Drysdale and Tim in swags by the fire. Once again there were
occasions when the past and present uncannily intersected.
'Took a photograph of a dead horse today. Quite uncanny –
it is exactly the picture I painted years ago.' They met various
aboriginals, and Drysdale saw one example of their superb
horsemanship. 'I'd climbed up a rock face to look at a curious
formation when I heard a furious clatter across the river in the
scrub, and looked down to see a mob of horses break clear and
pound across the rocky bed, with a boy on horse-back after
them at full gallop and hallooing like the devil. The way he

put his horse at the boulders and stones was horrifying, but the beast never faltered, and he headed off the mob.' He was also living among the realities of his favourite colours in his paintings: 'The ruddy red colour of the rocks is very deep in the evening light.' At the various camps he filled sketch books with drawings.

The shedding of the amenities of civilized life filled him with joy rather than regrets. 'Camp life, being what it is, lends itself naturally to a somewhat robust way of living, and the general simplicity of it tends to develop a bawdy sort of humour which everyone indulges in, and which couldn't translate to tiled bathrooms without losing its character and becoming commonplace and vulgar. There is no room for gentility, but at the same time there is every allowance for personal peculiarities.'

He was disgusted by the sight of a tourist shooting at a dingo with a .22 rifle, and the wounded animal running screaming into the distance. 'There's a bounty on dingoes, a quid a scalp, but that isn't the concern of the passing motorist. Leave it to the doggers who go about it as a job. To see an animal, native in its own environment, is always a good thing, and it brings back a lot of nostalgia for the days when one took it for granted as part of one's own environment. You forget these things when you live away from them, and they're a delight when you renew association with them. Because of that I can't pick up a rifle now, and shoot, and one remembers the many times in the past when an animal looked too good, the light too fine, the day too lovely, to kill, and you let him go. These great red 'roos that prop up and look at you, or flying in tremendous bounds, pacing a car at 40 miles an hour, excite one's admiration, not animosity.'

Ayers Rock, and also, further on, Mount Olga, are the biggest single rocks in the world, and the Drysdales were as impressed with them as they had expected to be, by night as well as by day. 'The wind, instead of tailing off, gained in intensity, and bitterly cold we pitched camp on the north side, some 400 yards from the north wall which rose sheer above us. The bright

116

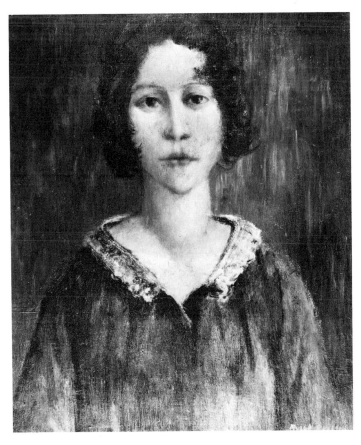

95 *Portrait of a Girl, 1955*

moonlight made the hollowed caves at the base eerie and immense with their intense black shadows. We sat round a fire that flared in the wind like a blow torch. Tim, shouting at the Rock in a fit of madness, was smartly answered back. By some freak of wind, the echo from some hollow or cave was strong and clear – carrying intonations and accent above the wind. We sat there shouting a variety of things, from the "Riverina Boys" to plain vulgarisms, and strongly back came the echo. It was more than an echo, it was a magnified and faithful reproduction that did not echo a word, but whole sentences.

It of course produced immediately a mad, friendly feeling and the great monstrosity of rock assumed straightaway an intimate personality. Not just Ayers Rock, a huge freak of nature, a wonder of the world, but old monster rock. We doled out a last, strong tot of rum and drank to the voice in the rock. The wind howled. About midnight, cold and shivering I woke in my swag, to find, in the white light of the moon, that my blankets and duffle coat had been blown yards off my bed. At seven we broke camp shivering in the wind, and with last salutations headed for the track back. The sun rising, overtook the setting moon – brilliant, glaring sunrise in the east, with a brilliant, glaring moon setting in the west. Quite bizarre. A world gone crazy.'

Ills. 40, 84 The real world was no less strange than that he had long ago painted, in *The Rabbiters* (1947) or *Full Moon* (1953).

Back again in Alice Springs, they restocked with provisions, enjoyed the luxury of a hot bath, and set off up the bitumen for Darwin. At Katherine they turned off to go crocodile hunting on the Daly River. One could guess from Drysdale's paintings that the lushness of the tropics would not appeal to him, and though he enjoyed the night boat trip after crocodiles, he did not care for the 'hot and humid, still and sinister' river, and in camp 'my old aversion to deep, dark trees kept me waking up'; and in the morning there was 'the deep green water sliding past, taking its cargoes of drift down on the tide – like the souls of the damned, doomed forever to drift in eternity, logs and bamboos, singly and in tightly compacted rafts, they move forever down the stream – only to meet the incoming rush of tidal water when they pause, and turning slowly come rushing back.'

At Darwin Bonny flew back to Sydney, and Drysdale and Tim flew in a light aircraft to Melville Island, where they witnessed the aboriginal Puckamanni ceremonies; some two years later, several notable paintings followed on this experience. Drysdale found the natives an extremely friendly lot, only too anxious for him to witness the corroboree, chatting

118

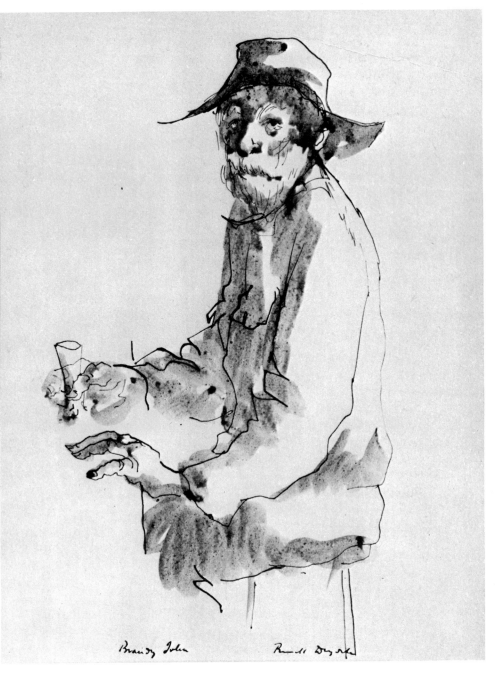

96 Brandy John, 1956

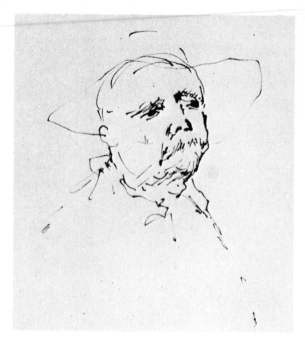

97 *Head, 1950s*

to him while they spent the day painting themselves and their wives, men with incongruous names like Laurie One-Eye, Ginger Two and Bob One; the man called King was in fact regarded as the King, and his mother, an ancient old crone, wore a headdress of one-pound notes. All these were to be engaged in the mourning ceremony around the carved and painted grave poles, but there was no sadness; it was in fact all very practical. 'On top of each pole were yards of printed cotton neatly folded – payment for the carvers and painters of the poles which is made at the end of the corroboree.' After preliminary dances huge fires were lit and by night-time the dancing was well under way. 'The area bright with firelight provided the most wonderful background with figures and groups standing outlined amongst the tall trees. A strange and savage sight. Grouped around the poles, sitting and lying, the painted figures looked weird and beautiful, completely masters in an environment made only for them – the black and white of ashes, the ochre of the beaten ground, the red of firelight,

the colour of the poles and faces. The smoke of cooking fires and burning logs, and the smoke from the wide spread perimeters of the burning grass reaching out to the low cliffs of the cape. The smell of sweat and naked bodies and burnt meat and wood ash. Dust rising from stamping feet, hoarse chanting, voices lifted high in song, and the constant beat of the rhythm, sometimes slow, then quickening to a crescendo. The traditional dances began – the Alligator, the Shark, the Canoe, the Fishing, etc., and of course today there are dances such as the aeroplane dance. . . . The man for whom this whole dance was held died last year, and was adequately enough called Charlie Pookamanni. All the natives here have European names which they give themselves – they find it convenient, as they don't by custom address each other by their native names individually, only by a "skin" name. A "skin" is a family grouping.' Drysdale particularly noticed Laurie One-Eye's tiny son Nelson, aged two and a half, at the payment dance. 'Clutching a gift in his little hand, and backed by his father and another elder he began stamping in time towards the recipient, whirling and shouting, then making the sudden dash forward. Afterwards he made his solo dance, running round and in between the poles, then going into a fast and furious stamping as the rhythmic dancing quickened, and then raising an arm with finger pointed, whirled round and stopped dead with the drumming. It was a fascinating sight. A tiny, fat, child.' Drysdale finally went to bed, 'my head full of the dance and imaginary compositions'.

After flying back to Darwin, Drysdale and Tim headed south-west in the Landrover for Hall's Creek, Derby, Broome and eventually Perth, more than two thousand miles of red dust, isolated stations and more dust. Broome was the place that interested Drysdale most, with its Malay town, its pearling luggers, and its own sleazy atmosphere; several more 'imaginary compositions' lodged in his head.

After Broome there was one marvellous break in the monotony of the sandy spinifex country, when the road swung

close to the sea. 'A great sweep of beach disappeared into mirage to east and west – the tide a mile out made the sun gleam across the vast great wastes of sand. The dunes were gleaming white, and the sand soft and powdery. Along various tidal levels as far as the eye could see the beach was covered in shells. We both gazed stupefied, and then like schoolchildren rushed shouting down the dunes, and searched the great heaps of shells. Masses of spider shells, and balers from large to small, white and coloured, all sorts and sizes and in beautiful condition. We felt like men who had come upon treasure. All by ourselves, the only people in a two-hundred-mile stretch upon that beach. Our sudden rush disturbed a group of pelicans who flew out a half mile towards the distant water's edge. The sun made the water gleam and the damp sand reflected the light so that it shone like silver. We spent an hour collecting shells and packing them into large cups of dry sponge that seemed to have been placed there for the purpose.'

No wonder it seemed strange near Geraldton to reach the first small farms they had seen since leaving the Queensland coast. 'We both started to laugh – it looked so strange. The unfamiliarity of the familiar.' Perth seemed even stranger. Lonely in the quiet respectability of St George's Terrace at night, Drysdale reflected on the odd life Australians have made for themselves in their vast new country, thinking 'St George's Terrace is the nicest street I've seen in Australia. It's boulevardian with just the right mixture of architecture, trees, width and space to make it so, but there is unfortunately that lurking touch of Calvinism in our national character which prevents us even from stepping buildings back another six feet on either side to give café terraces, and form an enlightened attitude to liquor consumption which makes it as readily procurable, and therefore as normally uninteresting, as toothpaste.

'I'm not comparing it with Paris; that sort of individual comparison is meaningless, but every European capital in the evening during the hour of strolling after dinner has that relaxation to offer. As a European off-shoot we've inherited

the climate of Greece, the light of the Mediterranean, the colour of Italy and Spain, and we live in it with the fearful expectation of an audience, gathered to hear Knox or Calvin thunder from the pulpit. Even with a large community of Catholics we endure, for instead of the ripeness of the Latin countries, they bequeath a puritanism which must be attributed to their Irish environment. Rebels in a cause but subjects. Children governing children, not adults governing adults, and always fearful that someone will walk in and indulgently ask how the game of grown ups is progressing. It only becomes apparent in the cities or the town. Where population becomes sparse, or where the distance becomes forbidding, rules and regulations are adapted to local custom which of course is based on good

98 *Aboriginal Group*, c. 1957

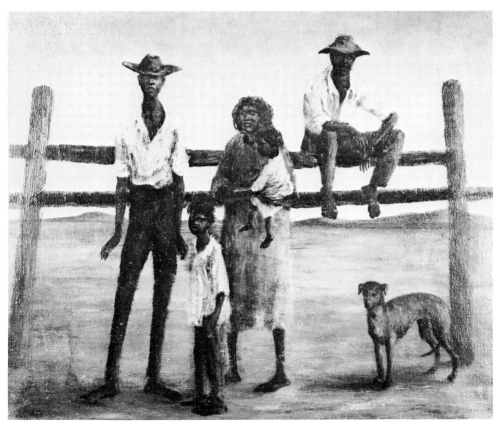

sense. In the far North West the hotels open from 9 in the morning until 11 at night as they do in the gold towns, on the grounds that the peculiar climate and exigencies warrant it. Legislature allows it. Whereas in a city, sophisticated in a manner unattainable by Hall's Creek or Derby, legislation clamps down. Obviously on the principle that the more there are, the less you can trust 'em. Which is a lopsided, and certainly an illogical viewpoint. Colonialism dies hard in a country that still solemnly intones the death sentence for rape. . . . A bottle of beer, taken from the refrigerator and placed cold upon the counter, has really no common meaning, for it can be viewed only from the environment of the legislated area in which one stands. In remote areas one views it without alarming perquisites; in more closely settled districts one eyes it warily, conscious that it can illogically accomplish with true legal concept far more than heaven, with its free and easy attitude, could conjecture. Therefore a man in Hall's Creek can walk with his face to heaven and a bottle of beer in his grasp on a Sunday morning, but in Onslow or Carnarvon the street is searched by anxious looks, and guilt enlarges the proportion of the bottle to astronomical size. For whose benefit, I wonder,

99 *Basketball at Broome, 1958*

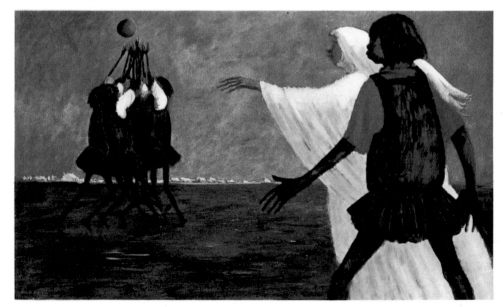

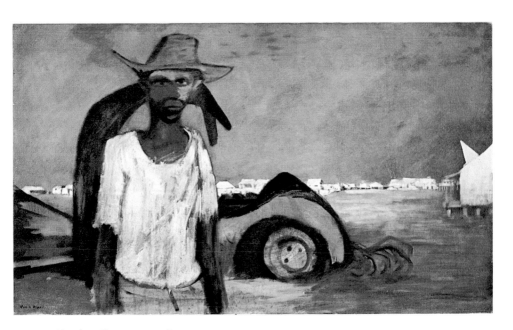

100 Youth at Broome, 1958

do we act so plain and then so strange. Such opposites of behaviour argue that a man accomplished in both attitudes is a man accustomed to dishonesty. How to explain to a simpleton let alone to a man of wit.' What a *cri de cœur*, and how many Australians would echo it!

From Perth the Drysdales drove east to Kalgoorlie, the Nullarbor Plain and Port Augusta, crossing the pass then to Quorn and the Flinders Range country, where of course in October it was green, and not the blazing reds that Drysdale had expected. Finally in Adelaide, in civilization again, the diary ends.

The extent of that 1956 journey, and Drysdale's comments on it, shows what a world it opened up for him as a painter and what joy it gave him as a man. Although the simple life of the camps, the meetings with drovers and station people and aborigines, the Puckamanni ceremony, the finding of the shells on the empty Western Australian beach were all part of a liberation into a freedom remote from the ordinary life of most

125

people, the journey was in no sense a romantic escape from reality. To anyone who has travelled and camped in those regions, the reality is around him, and any excessively romantic notions are brought down to earth by ants, flies or the day sweat and the night cold. Yet the elemental scale of it all, the loneliness that is both peace and excitement, must stir anyone with a shred of imagination. This opposition of the down-to-earth and the soaring, the practical and the incongruous, the personal and the elemental is exactly what appeals to Drysdale, and it is the reconciliation of these opposites that stimulates his imagination. Drysdale does not value these regions and their inhabitants for their picturesque qualities, nor because he wants to capture their sensational forms to bring them back and exhibit them in the artistic zoo, but because these are for him images of fundamental and universal validity, not to be found in everyday urban life. The words 'for him' are essential; of course any artist of great enough stature can find such images of validity anywhere it pleases him, like Michelangelo in the Last Judgement or like Van Gogh in a chair. But the link between image and artist must be sound, and Drysdale's honesty has always made him recognize this fact. The point needs stressing, for there are critics who argue along the lines that the true Australia is in the cities, not in the outback, and therefore an artist should paint city life. This is about as reasonable as saying that Renoir, in the 1914–18 period, should have been painting the war and not nudes. A much subtler approach was taken by Mungo MacCallum (*Quadrant* No. 19, 1961, pp. 84–6), who argued that Drysdale should now paint, not the inland of the bush, but the inland 'at the back of every city slicker's head, a usually subconscious sense of precariousness and alienation which we share with the figures of the bush, and which makes us go after symbols of tenure.' It should be clear by now that such an appeal is based on a complete misapprehension of Drysdale's thinking. In fact, his images are for him 'symbols of tenure' and not of alienation. His figures say: 'Look, we have come through!', even in the aftermath of tragedy.

The Aborigine and the Nude

Many of Drysdale's most striking and successful paintings followed on this 1956 journey, especially those painted in 1958 and 1959. In one group he developed his earlier fondness for the semi-surrealist effects that come from the juxtaposition of strange objects. Yet the incongruity, as already commented on, yields to that compelling unity imposed by the vastness of those lonely regions on all the disparate creatures and objects found there. Thus in *Native Dogger at Mt Olga* the bodies and *Ill. 101* heads of aboriginal and camel grow together so that the native's sad, sideways look is also part of the camel's confident leer. The scale is also ironically inverted, so that the stalks of vegetation, the man and the animals seem to dwarf the monstrous rocks in the distance. Drysdale had found Ayers Rock playful, as 'old monster rock', and so this enduring man and his beasts

101 Native Dogger at Mt Olga, 1958

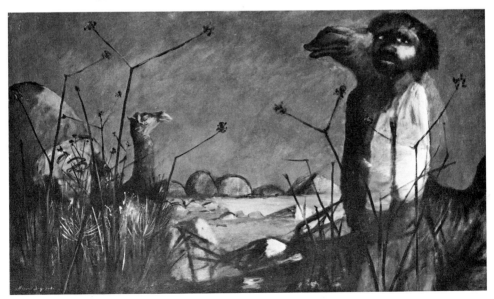

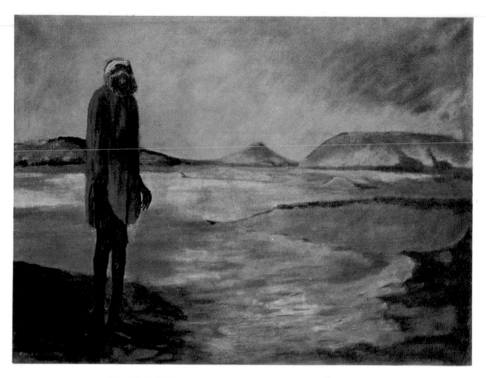

102 The Red Shirt, 1958

find Mount Olga a companionable group of pebbles. Even
Ill. 100 more bizarre, *Youth at Broome* shows the wreck of an old truck
apparently peering over the youth's shoulder like a dinosaur or
some prehistoric bird, while in the far distance the town, which
might be an orderly and solid affair, shimmers as insubstantially
as a mirage. Illusion and reality are co-existent, neither too sure
which is in command. The same puzzling town is in the distance
Ill. 99 of the highly dramatic *Basketball at Broome*, while in the fore-
and middle-ground the incongruity is left poised in the air like
the basketball which might be a sun or moon that will never
fall into those outstretched hands. And the nun, swooping like
a white-plumaged bird, guarded by the alert figure of the
aboriginal girl in the incongruous tunic, is herself both menac-
ing and protective. The drama is inherent, not arrested; this is

128

103 The Rainmaker, 1958

no high-speed frozen snapshot. Form contributes equally with colour to this result; the tremendous horizontal of the background is caught up again in the reaching forward of the foreground figures, while in the middle the group of girls fly vertically in a flurry of stick-legs and arms. It is a fascinating departure from Drysdale's favourite static poses.

Ill. 103

Ill. 102

Ills. 67, 102

Ill. 111

Ill. 103

Ills. 73, 104

The year 1958 also initiated entirely new developments in Drysdale's painting of the figure. *The Rainmaker* is a key work in this development, as can be seen by comparing it with a fine painting, *The Red Shirt*, of the same year. In the latter there are the familiar Drysdale properties of loneliness and distance, with those equally important compensatory characteristics of freedom and strength; the figure stands, half-beckoning, neither in flight from nor in fear of the landscape which, despite its barrenness throbs with rich colour that reaches its peak in the tattered splendour of the aborigine's red shirt. A clear line runs from *Mount White* (1953) through *The Red Shirt* to the fiercely compassionate *Mother and Child* of 1963, one of Drysdale's more recent achievements.

The Rainmaker is obviously by the same hand, but it is quite different in conception. Head and torso fill the painting as they do in *Old Larsen* or *Malay Boy, Broome* (1959), but the object is not to present the image of a man but of an idea, although the idea is humanist by association. The painting is considerably abstracted, but since the idea is humanist, not abstract, the human reference remains dominant. The idea in this case crosses the linguistic border into belief. It is magic, and as such it calls for the human intermediary between the everyday and the supernatural. The rainmaker is the man who by the use of various rites, and differing properties, influences nature to bring the life-giving rain. Art itself is an accessory to magic; in the Kimberley region the Wandjina are ancestral heroes of sacred powers related to rain and reproduction, and paintings of the Wandjina in caves are touched up in the dry season when rain is needed. A peculiarity of the painted face of the Wandjina is that it is mouthless below stylized eyes and nose, and a semi-

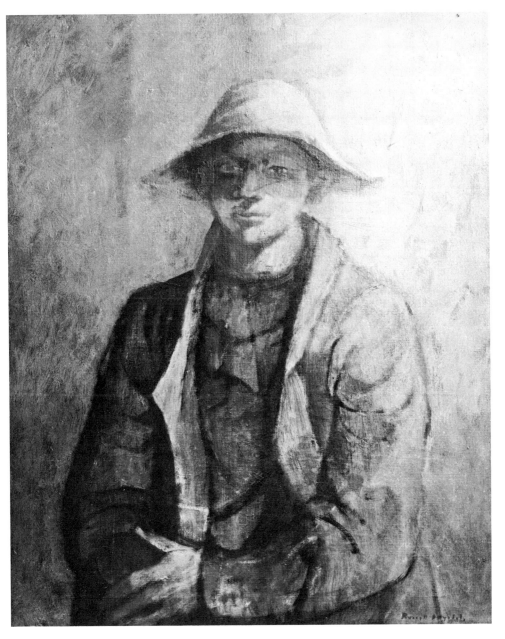

104 *Malay Boy, Broome, 1959*

105 *The Young Mourner, 1960*

106 *The Puckamanni, 1958*

halo sprouting a short growth of hair which delineates the top and sides of the head and also symbolizes rain. Drysdale's *Rainmaker* is neither an illustration of aboriginal beliefs nor a *Ill. 103* piece of *collage* in paint, using aboriginal motifs. In order to appreciate it one need not know what a rainmaker does, and one certainly need not know about the Wandjina. It makes its own statement, blurred and yet unified, as a red cloud of dust turns into rain which in turn comes down as liquid mud. The face is both human, planted on strong shoulders in an attitude of faith and command, and one of those faces that can be seen in clouds, that 'mock our eyes with air', in Shakespeare's words. There are no hard edges to the figure itself, and the spear, the one strong vertical, performs two functions, one leading

133

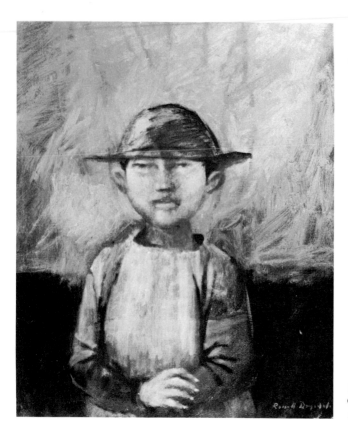

107
Chinese Boy, Darwin,
1958

upwards and one, like its barbs, pointing downwards. It recalls Drysdale's own description, quoted earlier, of 'rain like rods bursting into the dust'.

It is interesting to compare the dissolving face of this painting with those in many of Francis Bacon's works, and to speculate on the reasons why horror and disgust burst from the latter, and dignity and faith from the Drysdale. One reason, of course, is the texture and colour of the paint itself, which Bacon uses with loathing, as if the seductions of the medium were intolerable, and which Drysdale uses with love for its depth and for its glow that is both of the surface and the depth. Another reason is in the different attitude to life of the two painters. Bacon has stated that he detests it, and often can only approach

134

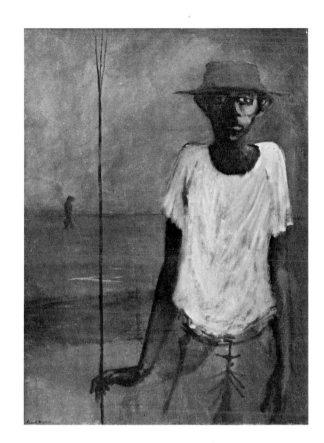

108
Man with a Fish Spear,
1958

109
Kimberley Landscape,
1958

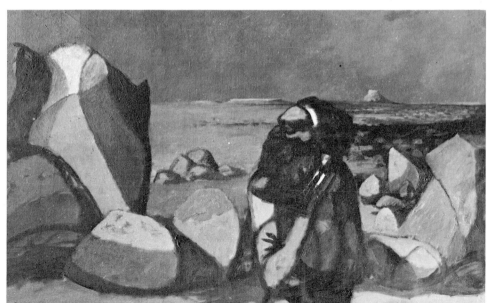

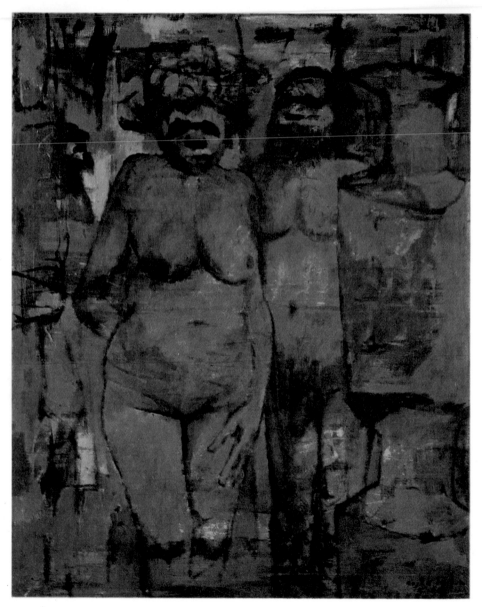

110 Man and Woman, 1960

it in paint through the derangement and degradation of drugs and drink. The humanist Drysdale has absorbed the destructive processes, sickness, injury, madness and death, but restores his sanity in his painting, taking as one of his favourite subjects the cycle of reproduction. As if life were not bad enough, Bacon wishes to project its disintegration into madness on to the surface of his scratchy canvas. The two have only one thing in common; each is a masterly draughtsman.

This could be the place to insist on the inescapable traces of national elements in art or literature, whatever the infinite personal variety of the creator. These traces emerge more strongly in mood than in subject matter, though the latter is of course more immediately obvious. Picasso's *Guernica* is as Spanish as Dostoevsky's *The Brothers Karamazov* is Russian. Bacon, who keeps photographs of Belsen and Buchenwald on the walls of his studio, also conveys much of what is most depressing in post-war England. In Australia, the artist or the novelist seems to emerge somewhat differently from his experience. Patrick White, for instance, not only has books like *The Rise and Fall of the Third Reich* or *The Scourge of the Swastika*

111 *Mother and Child, 1963*

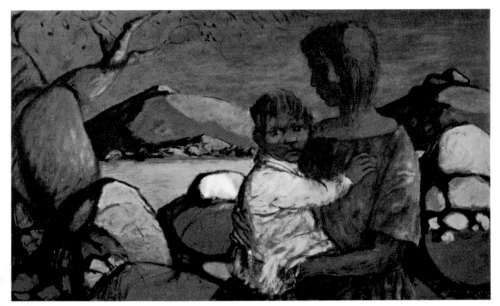

on his shelves but also has written about concentration camps. Yet what grows out of the horrors of his novels is not a fragmentative despair but a healing vision of a hard-won unity of existence. Nature will be renewed in the cycle of the seasons despite fire and drought. Similarly out of the fiery desert Drysdale paints the magic intercessor who will refertilize earth, man and animal; the mother and child amidst the rocks; the young mourner whose nubile nakedness promises life as she stands by the evidence of death.

Ill. 105

Drysdale's temperament is completely different from White's, yet the traces are clear in their work of the same affirmation; one can also find in them a common love of their different media, of paint and words. Moreover, neither of them is a simple Australian; they were both born in England and have lived many years in Europe. Any affirmation is not the result of *naïveté*, parochialism, or ignorance of the worst life can offer

112 *Red Landscape, 1958*

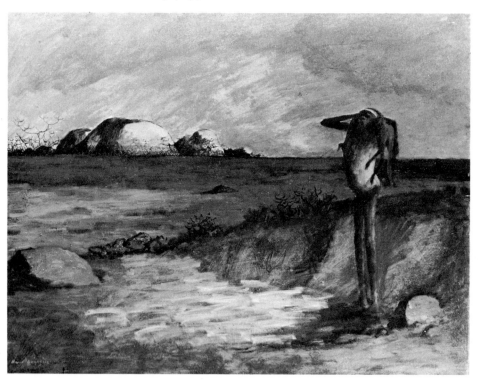

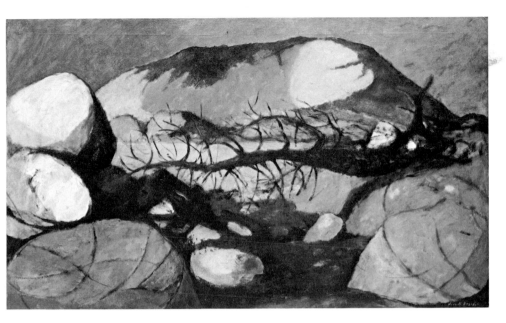

113 *North Australian Landscape, 1959*

in the twentieth century. A few explanatory clichés immediately spring to mind: Australia is a young country with an expanding economy that has never known on its own soil the ravages of war. As with most clichés, a grain of truth is smothered by husks of misinterpretation. White, for instance, on his return to Australia settled on a patch of land and planted trees and bred animals; Drysdale takes very seriously his responsibilities to Pioneer Sugar Mills, where, apart from sugar, there are big development schemes under way for the opening up of brigalow country to carry cattle. Such activities do not amount to any shallow identification with an alleged national ethos; artists are creatures much too complicated for that, which is best left to politicians. Nor could such activities be twisted into any day-to-day affinity with the life of most Australian city-dwelling writers or painters. Yet however asphalt-bound Melbourne or Sydney may be, the outlying realities are just not the same as those outside London or Paris. The most urban

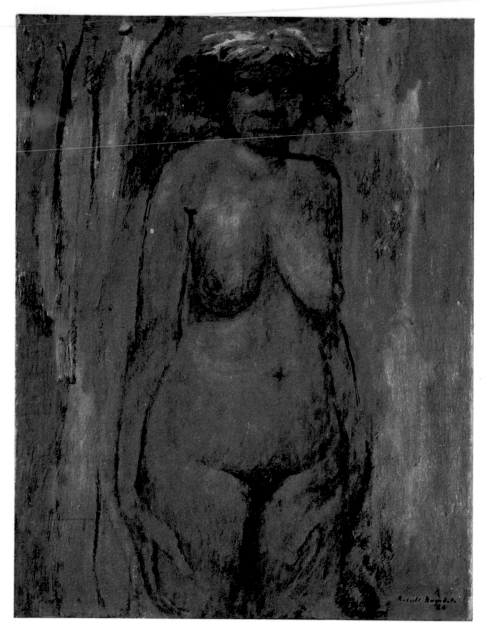

114 *The Woman Mangula, 1961*

Australian painters are likely to go and refresh themselves in these realities, like John Olsen in his 'You Beaut Country' or Fred Williams in his tree-dotted hills. Even the raw realities of the suburbs have an analogy with the virgin country being opened up for settlement: they are untouched material which has to be transformed by art.

It is very hard, though not of course impossible, to achieve ennui in Australia, the *taedium vitae* which is essentially that of a highly civilized person with too little to do beyond eating and drinking to excess. This was the worm gnawing at the gross-humoured frame of someone even as hard-working as Dr Johnson. Nor, as has already been remarked, is there a ready transference to religious states of mind amongst Australians. Suburban boredom is, of course, another matter, and it is

115 Man in a Landscape, 1963

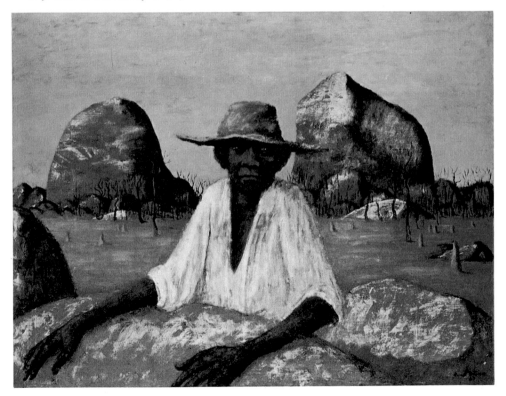

exorcized by the feverish activity remarked on by D.H. Lawrence forty years ago: 'They rush round like so many mechanical animals.' The theme of 'work to be done' extends to a thousand pursuits from do-it-yourself to mowing lawns to chasing balls or waves; the theme of idleness is expressed by lying amongst thousands of other people on hot beaches. The blessing of the artist is that he cannot tolerate boredom, and his curse is that he cannot enjoy idleness.

> Sing we for love and idleness,
> Naught else is worth the having

But the poet is already writing a poem about it, and the artist reaching for his brushes, and even contemplation is made strenuous.

It is easy to follow in Drysdale's work these apparently opposing streams, the contemplative-idle, the practical-active, that in fact join in every major artist. Those vast landscapes and elementally simple characters which would spell boredom to most strangers are an affirmation of freedom to Drysdale, and the lonely bore-sinker or dogger is about a satisfying job, just as the more visionary rainmaker, or the dancer at the Pucka-manni ceremony, is in touch both with magic and the basic necessities of life. Even when the human figure is almost dissolved into a wraith that is part of the background of fire *Ill. 106* (for instance *The Puckamanni*), the human spirit gives it a vertical strength greater than that, seeming more tangible, of the leaning grave-posts.

Ill. 116 In paintings like *Snake Bay at Night* or *Mangula* of 1961 the carved and painted graveposts move into the foreground and the still and painted figures are sometimes half-hidden behind them. Space, that familiar essence of most Drysdale paintings, is abandoned in favour of mass; the whole picture tends to become a formal arrangement of areas of interlocked colour, although the living image remains dominant and Drysdale never goes as far as the purely abstract. These works are so stylized that any element of dramatic action becomes intrusive.

142

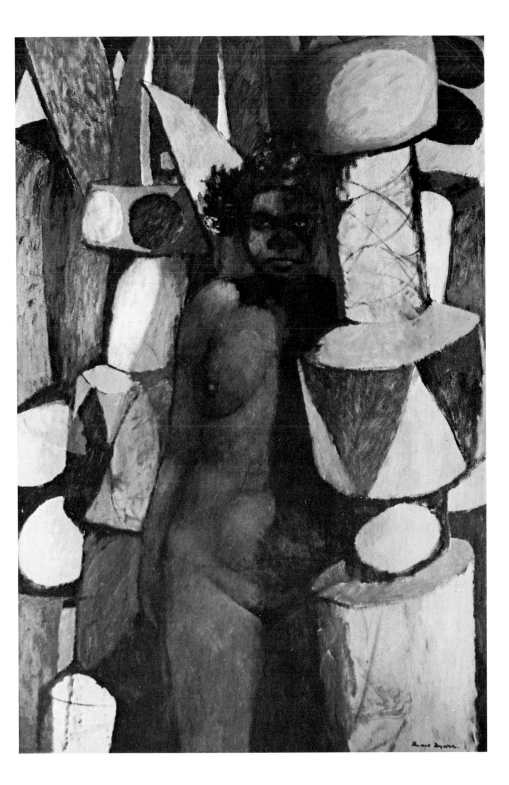

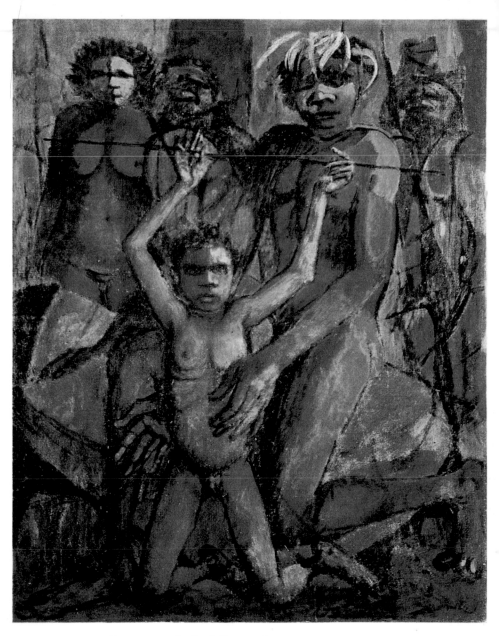

117 Ceremony at the Rock Face, 1963

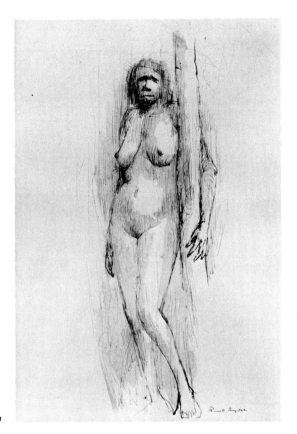

118
Melville Island Lubra, 1960

This is a fault of *Mangula*, however satisfying it is in nonvisual conception; for once, in Drysdale, the imagination of the man and the artist have not quite fused.

From the earlier period, there is a more successful juxtaposition in the very fine *Man and Woman*, where a thin, scraped paint of low-keyed but earth-rich brown holds figures and pole together with the utmost economy, and definition of shape is given by a simple framework of drawing. Space, again, is almost ignored. Following these directions, the paintings of the 1960–61 period tended to dispose brilliantly-handled details statically within the framework available (*Man with Galah*) or else dwell lovingly but unerotically on the female nude (*The Woman Mangula*).

Ill. 110

Ill. 114

145

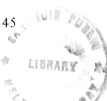

Sir Kenneth Clark, in that inexhaustible compendium *The Nude*, has given a great number of different examples of this paradoxical ability of the artist, especially when painting the nude, to be both passionately involved and deliberately aloof. One of his chief themes, he says, is that 'an austere tradition of design is an essential of the nude' (p. 121), and again (p. 23): 'The nude remains the most complete example of the transmutation of matter into form.' Granting this steady-eyed, unflinching approach, the nudes of Drysdale's post-1958 paintings nevertheless do not quite fit into any of the nine categories under which Sir Kenneth considers the nude.

Ills. 6, 7

Ill. 24

Ills. 30, 31

Beginning clearly enough as a brilliant student of the Matisse of *Le Nu bleu* (as in the paintings on glass done at George Bell's) Drysdale turned back towards the Degas-like naturalism of *Woman Sleeping* or *Woman Filing her Nails* where, despite the astringencies of the settings, the partially draped bodies are sensual if not demandingly erotic. At the same time his drawings, such as the confident *Nudes*, stay closer to Matisse, logical but endowed with the richness of Venus. From 1945 until 1958, Drysdale appears to have abandoned the nude. Then, with the images of the 1956 northern journey swarming in his mind, he began to paint the nude not only with great authority but from a concept for which it is extremely difficult to find any exemplars beyond the unclothed figures of the aboriginals themselves.

Sir Kenneth Clark draws the linguistic distinction between naked, meaning deprived of clothes, and nude, which projects an image of 'a balanced, prosperous and confident body'. It is an odd omission from Sir Kenneth's admirable book, which takes in prehistoric and Indian as well as European art, that under none of his categories of the nude is there any mention of Gauguin. Yet his Tahitian figures deserve each of the adjectives used above to describe the image of the nude, and they generate enough warmth to take the frost off all the nineteenth-century academies of Europe. Their sense of belonging is the essence of their openness, but although they accept both the flowers and the sun there is also for Gauguin the painter

146

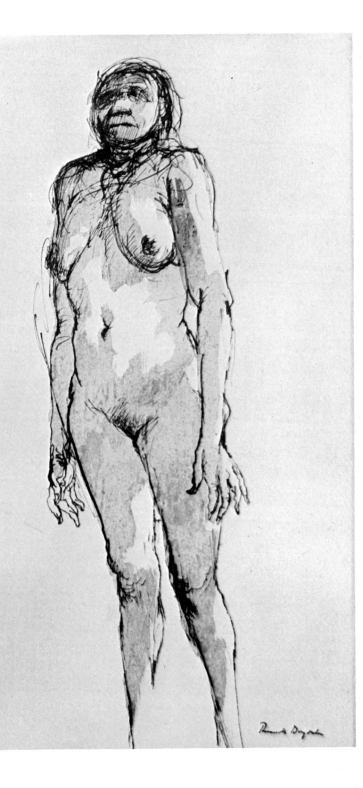

an inturned mystery about them. Their freedom could never be his, and this despite his intimacy with the sexual freedom of the Tahitians. Sometimes this mystery is accentuated by the presence of an idol or some barbarous symbol, but, as Gauguin himself said: 'The enigma at the bottom of their childlike eyes remains incommunicable.'

Such a non-European development of the nude has remained important but exotic. Drysdale is a rare example of an artist who has carried that development a stage further, while remaining in the general tradition of European art, and at the same time has given a new mystery to the universal image of the nude. Drysdale has learnt from Gauguin's use of flat areas of colour in and around the body, from his aim 'to clothe the idea in visual form'. But this is an analogy rather than an influence; Drysdale has probably consciously learnt nothing more from Gauguin than he learnt from all the painting he discovered in his early days in Paris. Moreover, Drysdale did not have to go to faraway Tahiti to discover his nudes; he found them in the heart of his own country. Like Gauguin's Tahitians they are Eve without shame, but they are also infinitely remote. Their enigma is intensified by the artist's distance, which is as far sensually as it is intellectually.

Nevertheless, they are not exotic figures of escape, but present in an actual landscape much loved by the painter. Their darkness turns into light as he moves closer to them. The very process is described by Drysdale himself in an account of one of their sacred grounds in the far North-West. 'The full glare of the midday sun beats back from the rock with an intensity that is painful, while the shadows cast in the lee of the stones are black as onyx. If you walk within these shadows, the pitch black melts into warm reflections of muted colour over the granular surface of the stone. The rock glows in soft tones that change from ochre into madder and from madder into blue. An occasional streak of yellow or livid vermilion bursts like a flame.' ('Journey to Gallery Hill', *Art and Australia*, May 1963, p. 27.)

148

120 Two Native Dancing Figures, c. 1960

The texture of the naked aboriginal skin, bathed in the shadows or the nights or fires of the hot north, draws out all Drysdale's sensuous love of paint. Yet there is a total absence of erotic sensuality in his approach to the aboriginal nude figure itself. Sir Kenneth Clark has called Titian 'the sun of sensuality' and a tropical sun of pure sex glows from Gauguin's *Et l'or de leurs corps*. As a painter, in his disposition of colour and form, Drysdale has something of Titian and something of Gauguin. But his aboriginal nudes, however nubile or fertile in themselves, are quite inviolate from the gaze that the artist transfers to those who later see his painting. They stand, dignified, almost ceremonial, like participants in sacred rites; there is something

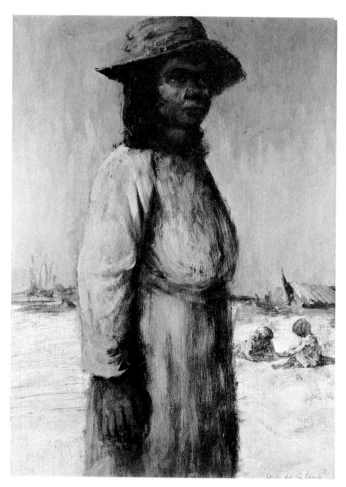

121 *Study, 1961*

in them, indeed, of the myths of certain aboriginal tribes who consider that woman is the origin of all things sacred, but that the secrets of her sacred rituals were stolen from her by men. It is as if Drysdale has discovered in the aboriginal nude a model that can unite the sacred and the profane by virtue of its primitive innocence. Sir Kenneth Clark has written of Renoir's nudes that 'in the unselfconscious acceptance of their nudity they are perhaps more Greek than any nudes painted since the Renaissance, and come closest to attaining the antique balance between truth and the ideal.' Drysdale's nudes have this balance, but they are primitive, they precede the classical; there is no trace of artfulness in the disposition of their bodies.

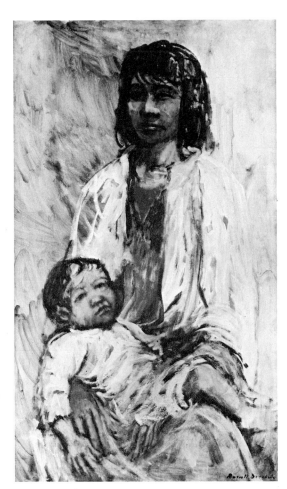

122
Mother and Child,
1961

Yet Drysdale, with the scientific side of his mind always alert, is well aware of the complex hidden web of ritual and belief that clothes his naked forms. They are surrounded by symbols; dreams and myths float above them; art and poetry are part of their lives. (There is plenty of room for the erotic in their art. Drysdale has photographed their paintings and inscriptions, and says of those at Gallery Hill: 'The astonishing majority depict human figures most of which are endowed with sexual and erotic symbols. Some depict actual birth, and some the act of coitus. In fact the coming into being of life.' Drysdale, so far at least, has not attempted to paint anything with the wild erotic freedom of these inscriptions.) It is, then, the knowledge of all that surrounds these figures that gives them their air of mystery. Without embarrassment they belong to the world of the flesh, but at the same time they are quite withdrawn from simple sensuality. They embody the paradox that the primitive is never straightforward. Amidst all the complexity of the twentieth century, one of Renoir's girls is as sweet, as beautiful

Ill. 114 and as perfect in herself as a ripe fruit; Drysdale's Mangula, still in the Stone Age, guards all the mysteries of life.

The tragedy of the aborigines is that they have survived into the twentieth century. Drysdale is well aware what this means, not only from experience culled from several trips to the north of Queensland, Central Australia, the Northern Territory and Western Australia, but also from a journey around aboriginal settlements in New South Wales, close to civilization, which he undertook for the Sydney *Sunday Mirror* in 1961. As on the previous drought series for the *Sydney Morning Herald*, his companion was the journalist Keith Newman. The difficulties involved in approaching the subject were outlined by Newman in the second of three articles: 'The most dangerous generalization seems to lie in the word "aborigine" itself. It creates an image of a primitive man, inherently different from the European and still retaining some of the nobility and dignity of the savage in his tribal state. That is sheer illusion in N.S.W. We have barely 200 full-bloods and they have lost all vestiges of

152

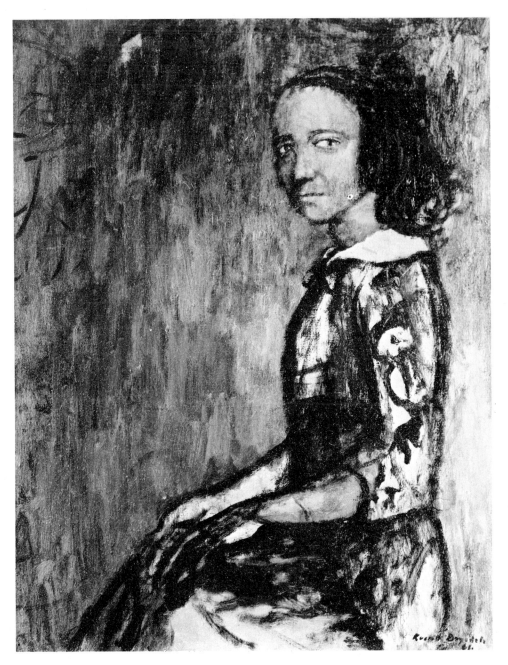

123 *Portrait, 1961*

Bones of a gold town.

R. D. u.

Caption: (At a distance the few buildings have
a solid appearance, but when one reached them...)

124 Drawing for 'Journey Among Men', 1961

tribal disciplines and are absorbed into the half-caste groups. Even "half-caste" is an evasion. More than half of the problem 13,000 are more than half white, and some have only one-eighth aboriginal blood. At the last count, some years ago, there were 6,600 half-castes and 6,673 lesser castes. To be blunt, the problem of the "aborigines" is one of half-castes and poor whites.' (This, of course, is written about New South Wales and not about the country north or west.)

Drysdale published about twenty drawings as a result of this journey. He has always considered that an artist should not be too proud to be an illustrator, but the best of these drawings have a human relevance and an economy of statement that transcends any temporary journalistic significance. Whatever Drysdale's modest attitude, they rise above the definition of

125 *Drawing for 'Journey Among Men', 1961*

'illustration' given by Berenson: 'the mere reproduction of all those visual images, no matter how elaborate and significant, and no matter in what shapes they are cast, of which the form has no intrinsic merit of its own that we more or less consciously perceive'. (*Italian Painters of the Renaissance*, p. 85.)

It will be convenient here also to consider the drawings in *Journey among Men*, written in collaboration with Jock Marshall, which, although having their origin in a 1958 journey through the North-West, were not finally executed until 1961, and published in 1962. (Earlier versions appeared in the London *Observer* in 1959.)

Some of the best of these drawings are of scenes in pubs (e.g. *Mates* and *Moody's Bar, Hall's Creek*). This not only reflects Drysdale's fondness for pubs (shared by his highly unprofes-

Ills. 124, 125, 128

Ills. 126, 127

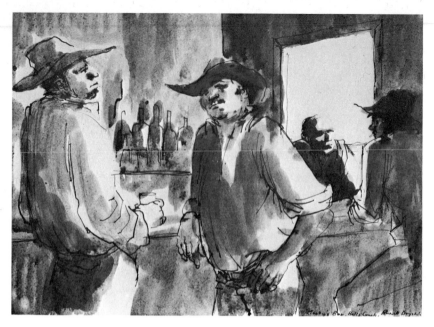

126 *Moody's Bar, Hall's Creek, 1961*

127 *Mates, 1959*

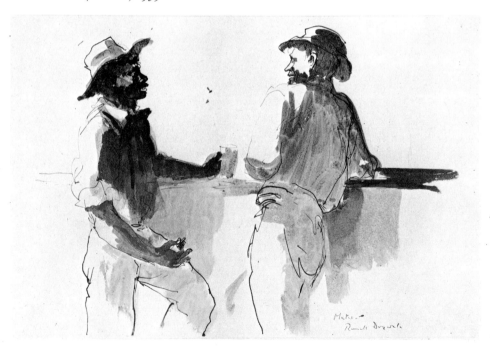

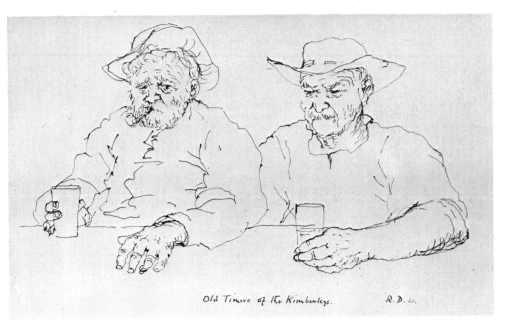

Old Timers of the Kimberleys. R. D. 61.

128 Drawing for 'Journey Among Men', 1961

sorial friend Jock Marshall) and his countryman's pleasure in standing around and yarning, but the pub provides him as an artist with incomparable opportunities for observing the relaxed human figure. Since he draws by memory, the informality is not disturbed. In both the drawings mentioned above there is a further opportunity that is also a further challenge, namely the formal contrast in stance between the 'aborigine' (using the word with Newman's caution) and the white man. Mates they may be, but they do not lean on a bar in the same way. Such observation, allied to such draughtsmanship, gives the form 'the intrinsic merit of its own' which Berenson demands. This is also nearly always true of Drysdale's drawings of children which are as honest as young children are themselves.

Drysdale's drawings are instantly recognizable as his, but it is hard to analyse their individuality. Partly, of course, it is their subject matter, the aboriginals of all sorts and colours, the stockmen, the men in bars, the hatters and old timers, men

157

129 *The Lovers, 1961*

wearing huge hats with wavy brims whose curve the pen lovingly follows, men with enormous hands (not a stylistic trick, but based on observation), and then of course the heaped boulders or the stringy verandahs that are parts of the Drysdale landscape. This is the selective eye at work, and no other artist has noticed or drawn such things. But what of the children, the

Ill. 38 mother and child, the old people? For instance, *Woman and Man Seated*, where the chairs are the furniture of their lives, and the weight of the air is in the laps opening out to their parted knees. Or a quick scribble of a child washing his foot under a tap where the askew stance, forming rigid diagonals,

Ill. 129 is yet so joyfully natural. Or the drawing of two lovers inspired

158

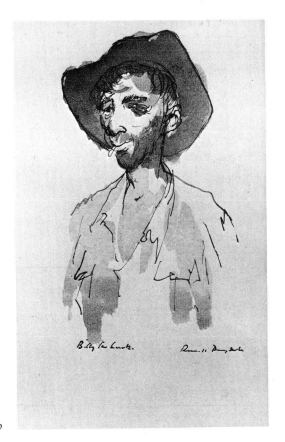

130 *Billy the Lurk, 1960*

by a poem of David Campbell's, where the interlocking arms
and legs build up such a solid structure to the two faces, and
yet lose nothing of tenderness and delicacy. These are all
classic subjects, and yet their universal quality is stamped with
Drysdale's style. The line and the wash are simple enough;
there is none of the mannerism with which he first experi-
mented. Perhaps it is some quality of gravity in a stare or the
set of shoulders, and in others (e.g. *Billy the Lurk*) a residual *Ill. 130*
sardonic stamina. Bearing in mind those who think Drysdale
is sometimes sentimental, it is also a complete lack of senti-
mentality in drawing children, whether dignified as in *Bush* *Ill. 132*
Children, or in the mood of 'I want it' – 'You can't have it' as

159

131 *Hawk and Hill, 1961*

in *Two Children*. Whatever else, Drysdale's drawings have an existence of their own; less and less, in his later work, are they conceived as studies for paintings.

Drysdale's career as a painter seemed to have reached its peak when in October–November 1960 he was honoured by a magnificent retrospective exhibition of 108 paintings at the Art Gallery of New South Wales. Not only the crowds turned out to do him homage but nearly all the critics as well, even the cagey ones. Moreover, his personal experience had been enriched by a year in London and Europe in 1957–58, towards the end of which he had had another successful exhibition at the Leicester Galleries, and then by accompanying Jock Marshall's zoological expedition to the Kimberleys and Central

160

132 *Bush Children, 1961*

Bush Children. R. D. 61.

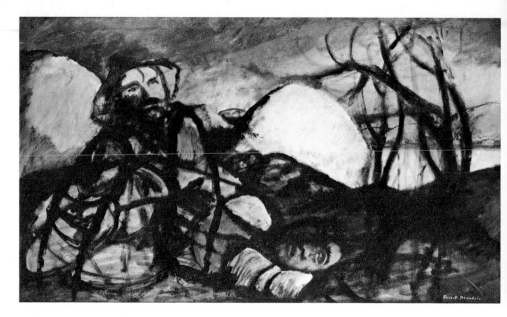

133 *Birders, 1961*

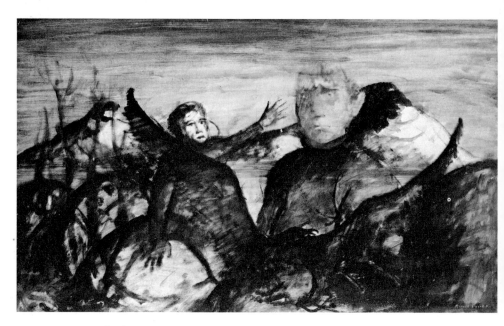

134 *Birders in Bass Strait, 1961*

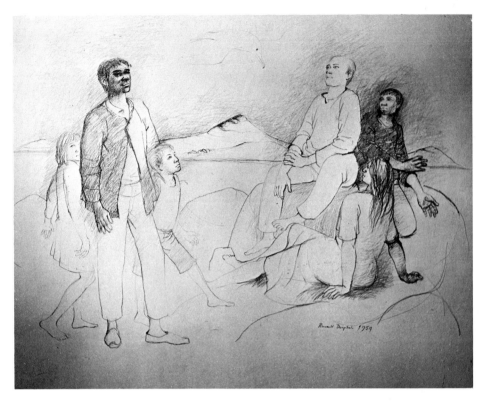

135 *Coming of the Mutton Bird, 1959*

Desert areas of Western Australia in 1958. Finally, his painting itself had acquired a new range and strength, which swung through into 1961 with some splendid results.

But as in a medieval tragedy this man so high on fortune's wheel was cast down into the worst trough of his life in 1962 and 1963. The works that emerged were sweated in blood through a period of acute psychological depression; it almost seemed as if the artist in the man had gone bush and there was no way of finding him. In 1962 his only son Tim died at the age of twenty-one. Although he continued to paint in 1963, and there were a few memorable results (*Rocky McCormack*, *Ill. 137*

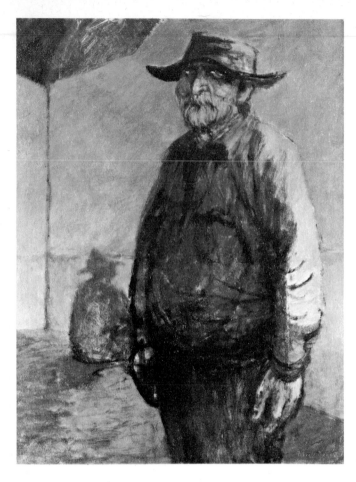

136
Old Harry, 1961

Ills. 115, 117 *Man in a Landscape, Ceremony at the Rock Face*) there was not a complete break-through of the old confidence until late in 1963, when Drysdale had been refreshed by a visit to one of his favourite haunts, the mutton-bird islands of Bass Strait (see the *Ill. 135* lovely earlier mural drawing, the *Coming of the Mutton Bird*) and a period of rethinking in Tasmania. In November, in a superb creative burst of energy, he painted the noble but tender *Ill. 111* *Mother and Child*, finished another painting and was about to start a third when he returned to Sydney from a quick visit to Canberra to find his wife Bonny dead in their flat.

164

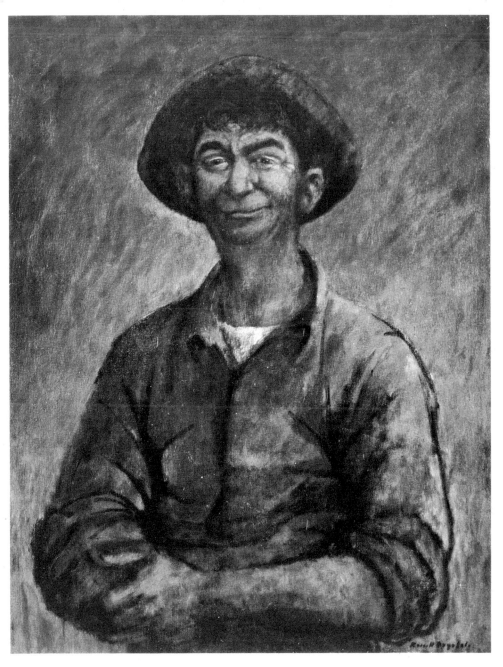

137 Rocky McCormack, 1963

The wounds in Drysdale's life have always led him to draw his creative bow more strongly than ever before. He has personally the dignity and strength of his own paintings, and the set of his head and the steadiness of his one good eye have not altered. An artist above all must be suspicious of good fortune, but at the same time, if he has the stature and the fortitude, he has within him the means to build himself even higher from the ruins of evil fortune. Great upheavals have always spurred Drysdale to his best work. One does not doubt that the worst two years of his life will be the making of the best to come.

Since 1964 Drysdale has been following up existing leads in his painting and drawing, while he has been building a new basis for his personal life. In 1964 he married Maisie, the widow of his old friend the painter Peter Purves Smith, and they have settled in a new house in the scrub, overlooking the Pacific Ocean, north of Sydney.

As a member of the Commonwealth Art Advisory Board, a Trustee of the Art Gallery of New South Wales, and an old master of modern Australian art whose paintings fetch alarming prices, Drysdale would seem to be in acute danger of becoming an Establishment figurehead. Picasso has demonstrated that the secret of eternal youth is to love woman, work and nature, and keep clear of the Establishment. Drysdale is well aware of the dangers he runs, and shows no signs of growing old.

A Self-Portrait

It is typical of Drysdale's distrust of the self that there should be no self-portrait of him in existence, either as a painting or a drawing. Nor is he inclined to talk about himself. The self-portrait in words that follows, therefore, must be regarded as a tribute to the invention of the tape-recorder, and also to a well-known brand of Scotch whisky. It was recorded in the artist's studio on three successive mornings on which the sun had not yet risen, since the hours in each case were between 3 a.m. and 5 a.m. Almost no editing of the tape has been done, except for the removal of odd phrases such as 'I like everything for breakfast'. Some information already given may be repeated here, but that does not matter very much. When you meet a man in person, after you have read about him, and he talks to you, you do not mind if he tells you a little of what you already know.

RUSSELL DRYSDALE: When you become a student then, it's rather odd at the age I was then, I felt naturally enough that the majority of students are people who have just left school, it's just like carrying on with another kind of school, and I felt a little apart in a way, and I couldn't really lead a student's life. I was a young married man eager to get on and in a way very much in the same position as young men who came back from the war, who were no longer just youths, but men. I felt too that I had a long time to catch up, so I used to work pretty hard, work at the school all day and then go home, work every night at home until ten o'clock and this went on week after week. I was subject to every influence that there was, I literally laid myself open for it, it was the one way in which you could garner in everything you could about art, it wasn't just modern art it was every sort of art, and also the art and craft of art.

I was lucky to have a good teacher in Bell. I'm afraid that when I look back on it, I'm not very good at remembering really the dates of what happened in the art world, the date of when the Contemporary Art Society was formed, who was concerned with what or anything, I've realized it always, when I look back that I had no interest whatsoever in the politics of art. One sort of had a loyalty to one's teacher – that I think is normal, but on the other hand I wasn't concerned with proselytizing causes. All I wanted to do was get on and work and try and make myself an artist. To me that seemed so much more important, and perhaps too, in a way, I was a bit older or maybe a bit more mature, I don't know what it is, with five or six years on the land, of pretty solid work too, and somehow I couldn't be interested in the organizing of art, or the organizing of a cause, or the formation of societies. That didn't interest me – it never has.

So that when I think of being a student, I'm really only concerned with how I felt myself, about painting. I can't even remember really what was known then as the days of the formation of modern art. I know I was part of it. What I think impresses me when I look back on it – you're not aware of course of it when you're a student – and that is the extraordinary ability that Bell had as a teacher. Not only was he a man who could talk to you sympathetically about art, but also about its craft, of which he had a great knowledge and which I particularly remember at the time being fascinated with. I wanted to know, for instance, it wasn't sufficient just to be able to sit down and paint or attempt to paint and draw, but I wanted to know about the materials that one used. I think probably it was a natural thing for me to ask because I'd been brought up in a condition in which when you're learning things as a jackeroo, for instance, you've damn well got to know what sort of materials you're going to use, or what sort of job you have to do, and you want specifically to know all the particular technical aspects that these things involve. You just can't handle stud sheep without knowing something about stud breeding,

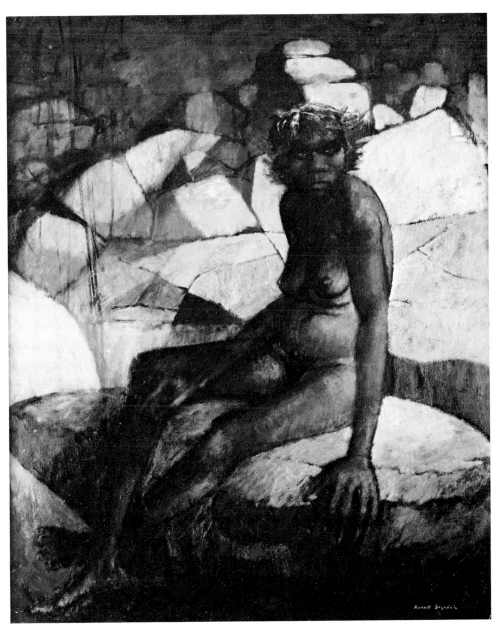

138 *Girl at the Rockpool, 1963*

it's quite obvious that you've got to, and you can't carry out the numbered and varied and sometimes highly skilled jobs that have to be done on a property without of course first of all acquiring the technique, or learning the technology of these particular tasks. I think that was one reason why it intrigued me tremendously, I wanted to know about the materials I was using, it didn't seem to me that it was sufficiently as easy as just buying tubes and squeezing the damn things. I wanted to know something about colour, the consistency of colour, how it was made, apart from its application, and I think anybody who has ever painted a fence and watched the paint peel off in the sun, he'll want to know something about grounds, what is the best ground to put paint on, so that it doesn't peel off. All those sort of simple things which I suppose one inquires into, well I got a tremendous response from Bell, he realized I really did want to know, and that out of his own fund of knowledge of this he taught me a lot.

The preparation of grounds, of canvases, the grinding of colour, the making of varnishes, the difference between paint which is applied and left, or the underpainting and then glazing, the difference between various mediums, the making of emulsions for tempera, all these things – to me they were all a part and parcel of it and a lot of it was good meat. These are sort of things that Bell knew, but that wasn't really just it, I mean there are a lot of peole who can show you these things, but they can't *teach* you them. I think Bell's ability was this, that he could always sense the stage which a student's mind had reached, and I think he sensed how much that mind could encompass and he never overburdened it with more than what a student could absorb at a particular time. And that I think was rather remarkable, that's an intuitive thing, and what it means is that the student can be taken along at his own rate and pace. That means he's not hurried through, thrown into two or three states of mind, on different aspects which might confuse him, but he gets everything completely clear and can absorb it. It's very difficult to explain this because there are people who

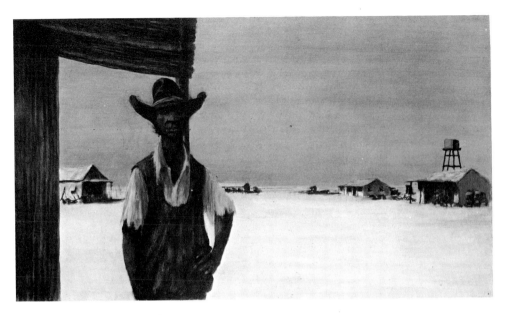

139 *The Out-Station, 1965*

I think are called 'born teachers' and those who teach by rule. Bell was a man, I hate using this word, who was a 'born teacher', he was an intuitive teacher, and an extremely able one.

I remember too that when he saw that I could draw he talked to me one day about this question of looking at objects and not just remembering them, but thinking about the essence of an object. I mean, if you looked at a jug, for instance, you considered that it wasn't just a jug but it was the essence of jugs, that all jugs had a shape because they had to conform, to *hold* something, so there had to be a confirmation of shape, and that when one drew from one's memory one should try and get this into a form which was the essence of a jug, an archetype if you like. There again, I don't like the use of these words, they tie you down too much, but this question of doing so was a great aid to memory and I found more and more that one could draw from memory. I remember too that Bell when he

saw one was interested in this, if a model was posed facing you, and you were drawing her from the full face position, Bell would say: 'Now look at her, the model, and think that you're sitting behind her and study the forms from where you're sitting now and draw her as though you were sitting behind her, and later on go and check up.'

Well, I used to do this, and I found it was fantastic – that one could really think and encompass forms, and apart from the anatomy that one was taught one could then begin to fit anatomy into its proper place. That meant that one's mind was always logically thinking of the sequence, of the blending if you like of forms logically one within the other. The framework was no longer just a two-dimensional framework but it was something which had thickness and depth, and the integration of each part logically moved, so that you could invariably think: 'Now if the model stood up or if the model lay down and rested on one elbow, the dispositions of those forms, of the other arm lying along the side, must, *must* come in that position, it's *got* to because it can't go any other way,' and as a result, one became aware always, without even thinking after a while, of the naturalness and disposition of forms.

This of course is, I think, a wonderful thing to be able to teach an individual to understand in these ways, so that it becomes a natural reaction and produces a natural understanding of what are after all apparently complex but on the other hand simply composed parts of one whole. This sounds a bit involved, it's difficult to explain, simply because I'm unconscious of it, these are things that are so natural to one that they become just part of one's thinking. I mean in the same way that if your leg is itchy, you scratch it. I don't think why I'm scratching it, so what happens is this, you begin to know how the forms go, you absorb them, and then it becomes second nature – it means that in your later life, when you do become a painter, this question of memory is I think a valuable thing, it means that if you go anywhere, and you're impressed with something you have in your mind, the memory of this, and

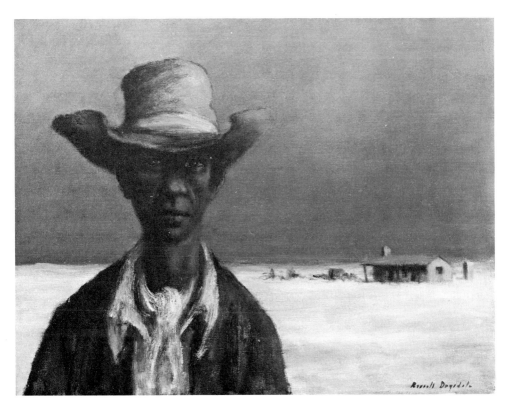

140 *Stockman, 1965*

what you really have, and what you start to delineate, are the essential characters and not the irrelevant details, which are of little interest, but the essential characters are what you retain in your mind. These are the things that you try and stress, these are the things that you don't necessarily have to think about, but which you are aware of, and which you're naturally utilizing to make, if you like, or bring out this peculiar quality of what you actually felt. All this is, if you like, a sort of maturation of the simple point on which you start as a student, with this attitude of placing together in a workmanlike design the component parts of a simple form. Well, let's say they're not so simple, they're complex, but the simple business of getting this fundamental fact tied together in the model, which you later

then carry right through the whole of the form of painting, whether it be landscape, still-life composition, all sorts of things, it comes back really to the fact that if you can, you integrate it.

Just another word further on this – this question of the use of the model, the human figure, quite apart from the aesthetics of it, purely from the point of view of the complexity of forms which are contained within one unit – the interesting thing that the model has is this, that one does not think of it virtually as a model at all, but as an assemblage of forms which are integrated. It's the difference, if you like, between a romantic and a classic attitude, there have been people who have elaborated it in this way. The romantic attitude is interested in the emotive fragment of forms, whereas the classic attitude is interested purely in the integration of forms. But whether it's either romantic or classical, the main thing is that the model combines these aspects. It can be purely a matter of abstraction, one can build an abstraction purely on these terms, but in the end it has nothing to do with realism or abstraction, it is only abstract in the sense that one conceives this as form. One doesn't look at the model and say: 'This is a human species.' One is not concerned with that. What one is doing is translating in terms of your mind an abstract concept which we call form and which we attempt to give significance to, because aesthetically we consider one form better than another, one shape better than another, because it seems to balance and have more cohesion and therefore work. And in the model you have this balance, you have this cohesion, you have a fluidity, you have all of these things, very difficult to be able to state, because you're translating this into a visual description, if you like, on paper.

Now this description does not necessarily have to be exactly what that model is. It can be a statement of what you consider to be the most pleasing arrangement of the balance which is placed before you. It may please you to such an extent that you want to exaggerate this pleasing aspect, this solidity of a seated figure, for instance, with the curve of a slight sideways posture which seems to be balanced again by that other form

174

of the head seated on top, you can do all sorts of things with this, it's the conception which is important. It is not the fact that one is concerned with any other aspect but this integration of form – or, having integrated it, let's see how we can disintegrate it. All these things become ponderable, and the important thing of course is the realization of it, and this comes back again to the fact that if you have a teacher who can make this thing possible, for you, then at last you have a view.

GEOFFREY DUTTON: Paris also helped to give you this view, didn't it, after you'd left George Bell's school?

RUSSELL DRYSDALE: I suppose to every man or woman who was ever a student in Paris when they were young there is that fantastic, quite wonderful appeal that Paris has. This hasn't anything to do with the fact that one is a painter or a writer or a musician or anything, but merely the fact that Paris, before the war, at least, was the gravitation point for students. And you can feel, still, the thrill of being in Paris. All the things that one had to see, or the fact that one was suddenly no longer just a student in a far, faraway land, but you were here, right to grips with all the sort of things that you wanted and wished to emulate. Here, if you wanted to see them, a bus ride away, was all the endeavour of hundreds, thousands if you like, of years, of civilization, gathered into places like the Louvre. All sorts of things like that, which you can't really express when you're young, you don't know how, but when you look back it was one of those, I suppose, tender moments in one's life which you will never have again, this sounds corny and frightfully romantic, I don't quite know how to express it anyway, but I think that anybody who has ever experienced that will understand, really. It is not just emotional, because after all it is overlaid with all sorts of things like the business of living, counting out money, wondering whether it is going to be easy enough to budget for the next week, but on the other hand you were living in the wings of, or under the shadow, if you like, of the wings of great men, of great, great things that had occurred in history, of works of art which, although you

175

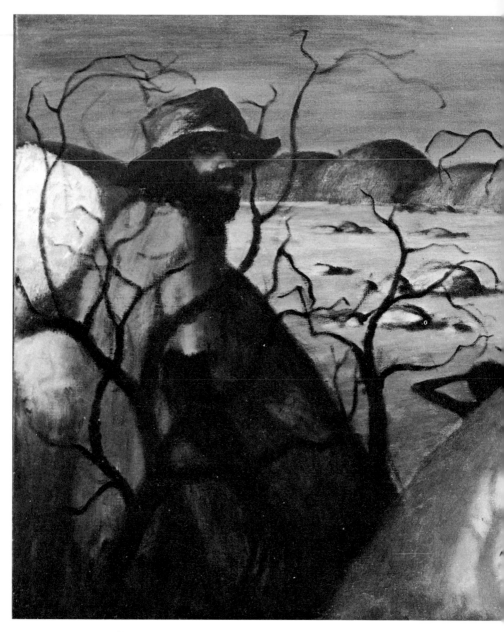

141 *Walkabout, 1965*

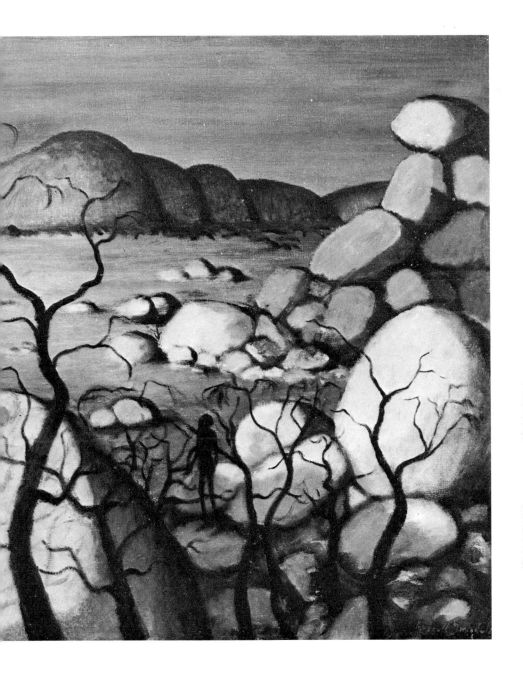

could wish to emulate, you could never hope to ever reach. All these things were frightfully important in those days, tremendously important, because one was young and one was reaching for impossible stars, and these, you know, were the sorts of stars, they were the big things. And then when you look back on it too, which you didn't realize because you were humble at the time, as you must be, when you are a student, you were living really in the same town and you used the same café, for instance, as people whose names today are landmarks in the history of art. Men like Chaim Soutine, simply because he happened to be a man who used the same café, and he used to ask the same question of Madame about her rheumatism in her shoulder. All sorts of small things like that. One was aware that Soutine was a great painter and that you were a student then, but on the other hand you had the busyness of being a student and therefore it was not necessary that you pay all this deference. It is only later in life, when Soutine is now dead, one is fifty, that one looks back and tries to recall that sort of atmosphere.

Paris was a place then which it will never be again, but in my knowledge Paris has probably never altered to anybody within himself, although it alters within one's life. It meant really that when you left Paris, as we did, because war was coming and we went back to England because it was difficult if you didn't know where money was coming from and you had a small child who was six months old, it meant that then there was this terrible dissatisfaction, and then finally we came back to Australia.

I realized then that one had suddenly stopped being a student anymore. One had the real necessity to be a painter.

George Bell was very kind, he gave me the use of his studio, which I painted in for a year, but they were still sort of formative things which I destroyed all the time because they didn't mean anything. I realized that I couldn't possibly ever go back again into an atmosphere in which I was a student, I had to go again into a totally different place in which there was no context

for me, some place in which I didn't know people, I didn't even know the landscape, that is to look out of your window and see that it was familiar. I wanted to be in a place where I could paint. I had terribly ill-formed ideas. Who hasn't when they try and start?

You know it's the most ridiculous impertinence that anybody could think of, that when one is young one seriously considers that you can *create* something! But you are not aware of this when you are young, but the impertinence is there, and I suppose this thing so weighed with me that I felt I had to try and essay what thousands of far better men had tried before. And I wanted to do it in a place where I had no distractions, where I knew nobody, and so I went to Sydney.

It wasn't easy, really. The war was on, I was in this position of thinking to myself, well, I must do what I must do, and all the friends of mine who belonged to a former life in the country had joined up. I, too, before I left Melbourne wanted to join up and I was rejected. And before I actually went to Sydney I thought, well – this unease of wondering whether you are half grown or not grown – I went out to a property to manage it for a friend of mine who had gone off and joined up. I managed the shearing and I looked after the property, but then it was ridiculous for me to do so, it was a fine great gesture, but one of the stock and station agents could do it far better than I could, and I had a wife and child. So I went to Sydney.

And from then on I began to paint. I don't quite know how I started to paint, all I remember is I destroyed a tremendous amount of things. I think after a while, of course, your own personal vanity catches up with you, you can't destroy too much, you know, you really *have* to look at what you do. Probably in a way your own vanity is something which is going to sink you at any time, but it can possibly save you, and I remember once when I painted a small picture, I didn't like it much, but I couldn't bear to destroy it, because it was the only *real* thing I had ever painted and I wanted to look at it, and I kept it for months. I looked at it and looked at it and

179

looked at it, and then I destroyed it, not because I thought it was bad or indifferent, but because I didn't want to be tied any more just to that.

Then I tried again, and so it went on, and in the end things began to arrive. I don't know whether they were good things or bad things, but they were things at least I could do. They were the things I could manage. Not easily, but they were in my scope. They didn't belong to anybody else. They belonged to me. If they had any intrinsic value it didn't really matter, in any case, who could care, because you couldn't sell them even if you wanted to.

I don't suppose anybody, if he is honest, can ever look back and say at any particular moment: 'This was something that I did which I knew was worthwhile.' I know it's a vanity that one is inclined to indulge in, and in retrospect one can say: 'That was the moment I did something which was really good.' But I can't really think of a moment like that, I can't. It's very hard. I remember certain pictures which I did, but they were pictures which I kept because they looked better than others, they seemed to be getting better, but it wasn't really because I thought they were good. It was because I suddenly realized nobody can ever paint without having things about him, and so I started to paint with a different attitude. I didn't wipe out the pictures I did because I was ashamed, or I didn't think they were good enough, but I began to string them around the place and start to look at them and compare them and – this sounds awfully factual in a way – but I think in times like that, when you're beginning to make and formulate your life you have to do it in your own way. This isn't the way other painters do it, possibly, or other individuals arrive at things, it isn't probably necessary that they do.

I have always found painting a very *difficult* thing, it's never been easy. Technically, I've always had to think carefully before what I have been doing, and whenever I've felt in later life that one is developing a sort of facility, then one stops, because I think quite frankly that it is far better to use the kind of

facility, or if you like the technical way of arriving at a picture, because the *subject itself* dictates it. So that, maybe, if you feel something about a particular thing, then maybe you have to apply a totally different way of painting it. The idea of being able to just learn how to paint and then apply it to subjects is something which I think is absolutely abhorrent, because it just means that the business of handling paint overrides anything that you might think. It's far better for what you feel to arrive in your mind. You should then have to think about how you will arrive at *it*, and you're not concerned with the fact that you can do it this way or do it that way, it's what you have in your mind that determines the way you do it. That's why it's not easy to paint. It's *hard* to paint. There's no known technique to make it easy.

I remember when I was young this was one of the things that I never consciously thought of, but why I found painting is hard is that somewhere unconsciously I believed this thing, and it caused a lot of heartburn, a lot of heartache for me, because it's not easy when you're young trying to be an artist to arrive at these things, or have the insight necessary to see these things. You just try and you work and by trial and error, and by more insight, and simply because you have become more and more involved with what you're doing and you can only think in terms of that, then do you begin to see some sort of way of arriving at a thing.

Conclusions will never be worthwhile. When you reach something which you think is pretty good, it's fine, put it up and look at it, consider it, hold it up to a mirror, do anything, admire it, but always remember in the back of your mind that it's always incomplete, because if it was really complete there would be no need to paint anything else.

When you've had a glut of it, because you must have, because when you can't sell pictures and when people tell you they're no damn good anyway, you've got to at least admire it yourself, because you owe that to the painting, a little bit of what you owe to yourself. And then you start another one. And so you

142 *The Red Lady, 1965*

go on. And in that way you go on painting, and then it becomes your life. Whether it's a good life, whether what you do is worth while, whether you accomplish anything or not really doesn't matter, not really in the end. The only thing that matters is that you've been able to do it, that you wanted to do it, more than anything, and I suppose in a way that's life.

GEOFFREY DUTTON: You were talking of technique. How do you like to use paint?

RUSSELL DRYSDALE: So far as mediums in painting are concerned I am not what is known as a direct painter, in the sense that one puts down paint and does not touch it. I am what is known as an indirect painter, I prefer to be able to build up an underpainting and glaze and paint into the glazes, and so forth. The old technique of painting, fat on lean, or lean on fat, cold on warm, or warm on cold, to me this gives paint a quality which I think is beautiful, I love it. There's a lusciousness about paint, there is a sort of thing that if you're just interested in paint is beautiful, and I feel that a picture – you know, secretly I feel if a picture, however exciting it might be, it's so much better if it can excite your tactile senses, so that you do want to step forward and touch it, simply because the surface is lovely. Because it has a beauty within itself. But this of course is a little specialized. Probably it sounds a little precious, I don't mean it to be precious, this is actually the workmanlike approach which I think all professional painters must have. Anybody who has ever seen a man painting a door, who's a good craftsman, if he's painting a front door for instance, you can see them in London, those beautifully painted front doors, with five or six coats all rubbed down, and you feel that every time they're rubbed down they're not done by the man who's rubbing them down as a chore, they're done with love, and feeling, so that finally that final coat goes down on, and he can stand back. And if you've ever seen a man when it's dried out thoroughly, he'll come and he'll run his hands lovingly over it, caressing the paint just to see how it feels, that's how I feel, a painter ought to feel about his medium. If people like Titian and

Rembrandt were not afraid to feel like that, who the hell am I to be frightened?

And it's perfectly true, I know that there is an awful lot talked about it, that there are painters who say: 'Oh don't bother me with technical things, all I want to do is express myself, painting is the only important thing, the main function of art is expression of oneself' – the only trouble about this, it's fine, it's grand, and it may have some logic, but how the hell can you express yourself unless you're going to use material to do it? And the curious thing about it is this, that the aestheticism of life doesn't depend necessarily on carrying out a prime objective, but it can also concern itself with the means with which you carry it out. It's not sufficient, for instance, to be able to say in bull-fighting the aim aesthetically is to please yourself and kill the bull. That is just not so. But peculiarly, it is the *manner* in which you kill the bull. And if you're going to paint, I don't think it's just sufficient to say that I'm a painter and I don't care two hoots about it. But if you're going to paint, let's think about the manner too, because curiously that manner comes out, whether you like it or not, in what we call the individual style of a painter. I don't know whether this is an important point. It doesn't matter whether it's important. As far as I'm concerned I could not care less. All I consider from my point of view, and being a painter naturally I'm damn selfish because I'm concerned with my point of view, and that is this, if you are going to paint for God's sake please all those sort of things in your self that you want to please.

GEOFFREY DUTTON: Then there's the subject, Tassy, there are certain people, characters, types, that especially seem to please you.

RUSSELL DRYSDALE: You were asking about people that I've painted, individuals, so-called characters, the people like Billy the Lurk and Old Larsen and others, as to why I paint them, why I like painting them. This of course is part of one's own life and one's own early experiences, these were the people virtually that one grew up with. And when you meet them as

143 *The Mourner, 1967*

you do throughout your life they're the sort of people whose common language you understand, because that was the language that you knew. I remember when I was young I probably was a little bored sometimes with listening to the tales of old men back in the twenties. I've often wished since that I had listened a little more to them, more earnestly. Pensioners, men in their late seventies, some of them getting on for eighty. In the twenties these were men who in their youth had been born about the eighteen-sixties, these were men who had shorn down the Darling and whose fathers before them reached back into the days of the ticket-of-leave men, the rural workers, the nomads, the shearers, the yard-builders, all those curious strange people who had little luggage but a swag, and who travelled and made and built the ethos that we know in the back country today. And even as a boy, a young lad, I virtually was in touch with it because I was talking to old men whose memories of their fathers' stories were still extant.

These are the things, the background, the sort of thing which lives in your blood, you're not aware of it, the sort of thing you come across in a camp somewhere out in the far west or in Queensland or in the Gulf, that when you walk into it and somebody hands you a billy and a mug and you sit down, you fall into a kind of easy talk that you've known for a long time. It's your life, it's not that one lives apart from it and because of that one outgrows it, you can never outgrow this, this is something which I think is part of the main spring that makes you, that directs you towards this sort of thing.

It's what makes me want to paint, basically, it's these things which in my youth impressed me, things that I loved, that I want to record properly for myself. I can't think I could ever paint a thing because I thought it was pretty or impressive, an impressive affair like the Sphinx of Egypt, I would never think of painting it – why? Because although it may be stupendous and cause awe in oneself it has no response, no responsive chord in myself, it doesn't in particular interest me. But, my God, you watch a mob of shearers coming out of any

186

shed, their actions today are exactly what the actions of other men were, the groups that form in the early mornings, with the dewy grass and men wandering their feet through the grass, getting into a knot in groups wondering whether they could declare the morning black because there's too much damp on the sheep, all the tricks and the humanities and the mad nonsense about it all, I don't know, it's something which is part of you, if you're brought up in it and know it you love it. The old men that always hung around the sheds in the old time, old men who had finished virtually with life but needed the happiness and comfort and the talk and cheer, men who all their life had been on the boards, they couldn't help it. They were the men who would just come along and volunteer to do just little jobs, anything, so long as they could sit and yarn, sit and yarn and talk, sharpen blades for men shearing stud sheep. All the old yarns, 'You remember Billy the Hoose', that type of thing, I don't know, Geoff, those are the people that are fascinating. They've got this character. They are characters. You can take your society people, however beautiful they might be, but to me they're ephemeral people. These others aren't. They just go on. They're the kind of towers that reach out. The survival thing that means something. These are the lessons learned at the knee.

GEOFFREY DUTTON: And what about the aborigines?

RUSSELL DRYSDALE: I don't know I've ever tried to analyse this question of painting aborigines. Somebody once said to me: 'You're doing something rather valuable, because this sort of thing will disappear one day and there won't be any records.' Well, I hadn't even thought of it like that, that might be of course from somebody's point of view quite valid, but I'm not really concerned with that, I don't know, I think it is simply because somehow in a way these people, they not only have to me a peculiar dignity and grace, not the sort of dignity or grace that one thinks of in the Apollo Belvedere, but the way in which a man comports himself in an environment which is his and has been his and his alone, he's at ease in it.

144 (pp. 188–9) Duststorm in the Central Desert

The way he sits with his feet in certain positions, his hands and feet are anatomically the same as yours, but they comport themselves with a certain difference, all this, all these sort of things are intriguing, they become part if you like, and yet they're not part of a landscape, they do stand out. It might be his landscape, certainly, on one hand, but on the other hand he is man, and to me this strange primitive quality is the same thing as in the landscape, it is part of the trees, and the rocks, and the river, it's man in this as he virtually was. This I know sounds terribly romantic!

GEOFFREY DUTTON: And this brings us to this much-discussed theme of loneliness.

RUSSELL DRYSDALE: On this question, Geoff, that we were talking about, this question of the loneliness in the outback and this frightening spectre which appears and which has now been discussed frequently in the press, I think it is very important to say this. I can very well understand why anybody in England, for instance, does think this is a powerful and strange and frightening spectre, almost, that hangs over you. But it is I think true as Max (Harris) said the other day, it *is* true, that, to me at least, and it must be for a lot of Australians, that there is no fright, there is no sense of loneliness. I don't think for instance anybody in the city of Sydney is really ever aware that there is, as a recent visiting journalist by name of James Morris stated, that everybody in Sydney always seems to be crouching down under the shadow of this great loneliness. I don't think most people in Sydney are even *aware* of it, they wouldn't have the faintest idea, but those people who *do* know, that have been into the back country, there is no loneliness for them at all. There is a great sense of freedom.

The most peculiar thing about Australia, and we always talk about it in terms of country, *our* country, whereas in effect what we are really talking about is a vast great continent, not a country at all. This thing ranges climatically from the tropic to the temperate zones, and although it has this great rigid shield, with the worn-down mountains, and the large area in

190

the interior which most people would call briefly desert, and which is not truly a desert, it has on the other hand (and this is quite peculiar for a large land mass such as this), it has nothing that is virtually frightening, that a sensible man could not combat. We have no savage animals, we have no predators that Africa has, we have no savage peoples, we have no endemic diseases, we have nothing that an ordinary, healthy man cannot combat. If for instance he is in lonely places or in arid conditions, where he can't expect help, all he needs to do is to make sure that he's got the means of subsistence for the time he's in that area.

He won't be lonely. He'll have the company of birds, the ubiquitous company of birds, he'll find that he's living on terms with them which he can never do normally, because the semi-desert growth or semi-desert as we call it, is populated by a zerophytic growth. This means that you do not have great tall trees, but you have birds nesting in trees as you would in a normal landscape, but they nest in stunted trees, which means that they come down to see you. You don't view them as you would in a forest of great flights, you see them at a lower level. They become curious of you, you find they're friendly and they're about you. You can never be lonely in areas like this.

Where is this great empty loneliness? If you like to look at the ground you'll find it peopled with insects and life, so much movement that's always going on. Where is this thing? This is only a matter of adjustment to scale. I think it's just what I was talking about before. I think I said that when people from London, for instance, saw these things, they were right to feel this sense of loneliness, because they have never had such an experience.

The point that they bring up about my paintings is that they depict a lone man in a landscape and therefore it's lonely. I don't, quite frankly, really mean to emphasize that there is a loneliness. There *is* a loneliness in everybody who lives apart, I quite agree, but this isn't the sole thing. What happens is this. You can delineate landscape, the bones of a landscape, and in this

country this age-old thing is tremendously gripping, but if you really want to point up a landscape that is deserted, then if you put somebody within it, you do two things. You point up the loneliness, not because it's the man that is in the landscape, but it's because the man is there that the landscape is lonely, unpeopled. At the same time, secondly, you can try and point out that this is a man, or man, *man*, just *man*, unconquered by landscape, because man is a species which has arisen like every other species on this earth and he is not *alien* to a landscape, otherwise he would have to live somewhere in outer space.

Bibliography

List of Illustrations

Index

Bibliography

ILLUSTRATED BOOKS AND ARTICLES

JOHN HETHERINGTON, *The Australian Soldier. A portrait.* F.H. Johnston, Sydney, 1943. Illustrated with 11 drawings.

ALLAN DAWES, *Soldier Superb. The Australian Fights in New Guinea.* F.H. Johnston, Sydney, 1943. Illustrated with 15 drawings.

Sydney Morning Herald, 16, 18, 19 December 1944. A series of drawings illustrating drought and soil erosion in western N.S.W. Subsequently in the Melbourne *Herald.*

The Observer, London, 3, 10, 17 May 1959. Drawings illustrating a series of articles on north-west Australia by Dr A.J. Marshall. Subsequently in the *Sydney Morning Herald,* Melbourne *Age* and elsewhere.

PAUL HAEFLIGER, (Introd.), *A Retrospective Exhibition of Paintings from 1937 to 1960.* Sydney, Ure Smith Ltd., for the Art Gallery of N.S.W., 1960. This contains Haefliger's Introduction, a Chronology, the Catalogue of the Retrospective Exhibition, 12 colour and 24 black-and-white plates, and a Bibliography. The catalogue entries, bibliography and other documentation are by Daniel Thomas.

Sydney Sunday Mirror, 12, 19, 26 March 1961. A series of drawings illustrating a survey by Keith Newman of the aboriginal problem in N.S.W.

Australian Letters, vol. 3, No. 3, March 1961. A series of drawings illustrating a sequence of poems by David Campbell.

Catalogue of the Drysdale Exhibition, Adelaide Festival of Arts 1964 (4–21 March) at the John Martin's Auditorium.

THE ARTIST'S OWN WRITINGS

'Art and the People', *Society of Artists Book,* 1942, Sydney.

Notes on Peter Purves Smith, William Dobell, Donald Friend and Elaine Haxton in *Australian Present-Day Art,* Sydney, 1943.

Foreword to the exhibition catalogue *U.S. War Paintings from MacArthur's New Guinea Campaign.* State Galleries in Brisbane, Melbourne, Adelaide and Sydney, October 1944–January 1945.

'What is Modern Art?', *Daily Telegraph,* Sydney, 27 January 1953. Opposing viewpoints from Russell Drysdale and Douglas Pratt.

Review of Jean Bellette's one-man show. *Sydney Morning Herald,* 30 June 1954.

'Capricornia', introduction to exhibition catalogue *Russell Drysdale.* Leicester Galleries, London, 1958.

Impressions of a Painter in Europe Today. A lecture with an introduction by Hal Missingham published by the Art Gallery Society of N.S.W. Sydney, 1959.

Introduction to *Form Colour Grandeur. A Photo Study of Central Australia* by Allen David. Melbourne, Grayflower Publications, 1962.

'Journey to Gallery Hill', *ART and Australia*, vol. 1, No. 1, May 1963.

JOCK MARSHALL and RUSSELL DRYSDALE, *Journey Among Men*. Hodder and Stoughton, London, 1962

MONOGRAPH

JOSEPH BURKE (Introd.), *The Paintings of Russell Drysdale*. Ure Smith Ltd., Sydney, 1951. The only individual study. It contains 15 colour plates, and a chronological list, supplied by the artist, of paintings up to 1950.

FAMILY BACKGROUND

P. L. BROWN (Ed.), *The Narrative of George Russell of Golf Hill*. Oxford, 1935.

P. L. BROWN (Ed.), *Clyde Company Papers* (4 vols. to date). Oxford, 1941– Details of the Drysdale and Russell families in eighteenth- and nineteenth-century Scotland and in Tasmania and Victoria from 1821 to 1850.

History of Queensland. Its People and Industries (3 vols.). Brisbane, 1919–23, vol. 3, pp. 717–725. Details of the Drysdale family in North Queensland from 1886.

REFERENCES IN BOOKS

SYDNEY URE SMITH (Ed.), *Australian Present-Day Art*. Sydney, 1943. A note on Drysdale by the editor and reproductions of 21 works.

DONALD FRIEND, *Gunner's Diary*. Sydney, 1943, pp. 17, 24–25, 35.

SYDNEY URE SMITH (Ed.), *Present-Day Art in Australia 2*. Sydney, 1945. A note on Drysdale's art by Paul Haefliger, and reproductions of five paintings.

BERNARD SMITH, *Place, Taste and Tradition. A Study of Australian Art since 1788*. Sydney, 1945, pp. 237–40 in chapter 'Realism in Australian Contemporary Art'.

Contemporary Australian Art Collected by Neil McEacharn. Ure Smith Ltd., Sydney, 1945. Printed for private distribution. Of the Drysdale illustrations two not available elsewhere.

DONALD FRIEND, *Painter's Journal*. Sydney, 1946, pp. 40–50, 72–73.

CLIVE TURNBULL, *Art Here, Buvelot to Nolan*. Hawthorn Press, Melbourne, 1947, pp. 26–29.

SYDNEY URE SMITH (Ed.), *A New Approach to Textile Designing by a Group of Australian Artists*. Sydney, 1947. Illustrates two textiles commissioned by Silk and Textile Printers Ltd.

SYDNEY URE SMITH and JOSEPH BURKE (Eds.), *Art and Design*. Sydney, 1949, p. 2.

HERBERT BADHAM, *A Study of Australian Art*. Currawong, Sydney, 1949, pp. 124–125, pl. 72.

URSULA HOFF (Ed.), *Masterpieces of the National Gallery of Victoria*. Cheshire, Melbourne, 1949, pp. 232–233.

CLIVE TURNBULL, 'The Painter's Art', *This Land of Ours*, George Farwell and F. H. Johnston (Eds.). Sydney, 1949.

SYDNEY URE SMITH (Ed.), *Present-Day Art in Australia*. Sydney, 1949. A revised edition of the 1943 and 1945 picture books from which six works by Drysdale are reproduced.

Art Gallery of N.S.W. *Illustrated Souvenir*. Sydney, 1951, pls. 38, 40.

COLIN MACINNES, 'The People. Their Art', *The Sunburnt Country. Profile of Australia*. Ian Bevan (Ed.), Sydney, 1953, pp. 190–191.

HERBERT BADHAM, *A Gallery of Australian Art*. Currawong, Sydney, 1954, pl. 36.

COLIN SIMPSON (Introd.). *Australian Image, Landscapes by Australian Painters*. Legend Press, Sydney, 1956, pl. 2.

DONALD FRIEND, *Hillendiana*. Sydney, 1956, pls. 16, 21–24. One drawing and four landscape photographs by Drysdale.

HERBERT BADHAM, 'Art', *The Australian Encyclopaedia*, vol. I. Sydney, 1958.

JOHN DOUGLAS PRINGLE, *Australian Accent*. London, 1958, pp. 121–123.

KYM BONYTHON (Ed.), *Modern Australian Painting and Sculpture 1950–60*. Kym Bonython, Adelaide, 1960. Three works reproduced and see introd. by Laurie Thomas, p. 6.

National Gallery of South Australia. *Picture Book*. Adelaide, 1960, pl. 13.

Antipodean Vision, Catalogue of the 1962 Tate Gallery Exhibition of Australian Art.

JOHN DOUGLAS PRINGLE, *Australian Painting Today*. Thames and Hudson, London, 1963.

JOHN HETHERINGTON, *Australian Painters: Forty Profiles*. F. W. Cheshire, Melbourne, 1963, pp. 109–120.

REFERENCES IN PERIODICALS

The Studio: London.
BASIL BURDETT, 1938, Jan., 'Australian Art Today', p. 10.
SYDNEY URE SMITH (Compiler), 1942, Oct. Special Number, 'Australia in Art', p. 120. 1943, April, p. 129.
G. S. WHITTET, 1951, April, review of one-man show, p. 122.
ARNOLD SHORE, 1953, May, 'Contemporary Australian Painting', p. 134.
HAL MISSINGHAM, 1957, Feb., 'Recent Australian Painting', pp. 33–41.
 1958, July, review of one-man show, p. 28.
JOHN RUSSELL, 1965, 'Russell Drysdale'.

Art in Australia: Sydney.
 1938, Nov. Special Number, 'New Trends in Australian Art'.
GINO NIBBI, 1939, Aug., 'Ideas behind Contemporary Art', with reproduction of a picture since painted over.
 1940, Nov., reproduction of a picture since painted over, p. 35.
 1941, March, reproduction of a picture since painted over, p. 68.
 1942, March, 'Two Australian Painters' (Dobell and Drysdale), pp. 63–67.

Magazine of Art: Washington, D.C.
THEODORE SIZER, 1941, Oct., 'Art from Australia', p. 418.

Society of Artists Book: Sydney.
 1942–46, annuals, various references.

A.N.J. (Australia National Journal): Sydney.
 1942, April, six reproductions. Two not available elsewhere.

National Gallery of South Australia *Bulletin:* Adelaide.
1943, Oct., vol. 5, No. 2. 1948, April, vol. 9, No. 4. 1949, July, vol. 11, No. 9.
1953, Oct., vol. 15, No. 2.

Art News: New York.
EDGAR KAUFMANN, 1944, Oct., 'On Leave with Australian Art', reprinted
Sydney Morning Herald, with Drysdale's drought illustrations, 16 Dec. 1944.

Meanjin: Melbourne.
1945, vol. 4, No. 2, pp. 109–111.
BERNARD SMITH, 1951, 'Fifty Years of Painting in Australia', vol. 10, No. 4,
p. 358.
ALAN MCCULLOCH, 1952, Australian 'Expressionism' (a reply to Bernard
Smith's article), vol. 11, No. 1, p. 46.

National Gallery of Victoria *Bulletin:* Melbourne.
1945, vol. 1, No. 2. 1948, vol. 3, No. 1. 1951, vol. 5, No. 1. 1954, vol. 8, No. 2.
1958, vol. 12, No. 3.

The Australian Artist: Victorian Artists' Society, Melbourne.
1948, Autumn, vol. 1, Part 3, p. 45. 1948, Winter, vol. 1, Part 4, p. 56.

A.M (Australian Monthly): Sydney.
D. L. THOMPSON, 1948, Nov. 'Drysdale, Painter of Harsh Truths', pp. 32–33.
SUSAN WAKE, 1952, May, 'A Ghost Town comes to Life', p. 17.

Illustrated London News.
1950, 16 Dec., p. 1005.

Art News and Review: London.
ERIC NEWTON, 1950, 16 Dec., review of one-man show, p. 2.
MARY SORRELL, 1953, 8 Aug., review of Arts Council Exhibition, p. 4.
KEITH SUTTON, 1958, April, review of one-man show, p. 10.

Canadian Art: Ottawa.
STEWART JAMIESON, 1950, 'Australian Art. Some Comparisons with Canadian
Paintings', vol. 7, No. 4.

The Listener: London.
BERNARD SMITH, 1950, 30 Nov., 'The Artist's Vision of Australia'.

The Geographical Magazine: London.
MAIE CASEY, 1952, June, 'Russell Drysdale and the Australian Countryside',
pp. 64–69.

Architectural Review: London.
ROBERT MELVILLE, 1953, Oct., review of Arts Council Exhibition, p. 262.
ROBERT MELVILLE, 1958, July, review of one-man show, p. 57.

Vogue: London.
LAURIE THOMAS, 1956, Jan., 'Australian Art. Its International Place'. Supplement
for Australia, No. 1, pp. 62–63.

Journal of the Royal Society of Arts: London.
 D. J. FINLEY, 1957, June, 'Art in Australia: Looking both Ways', p. 610.

Artist: London.
 1957, June, 'Contemporary Art of the World', p. 84.

Burlington Magazine: London.
 D. L. A. FARR, 1958, May, review of one-man show, p. 186.
 K. ROBERTS, 1965, review of Exhibition at Leicester galleries.

Apollo: London.
 1958, May, review of one-man show, p. 152.
 J. BURR, 1965, review of Exhibition at Leicester galleries.

Australian Letters: Adelaide.
 1959, June, painting reproduced on cover.
 NANCY CATO, 1960, March, 'Art in South Australia', pp. 75–76.

Art Gallery of New South Wales Quarterly: Sydney.
 JAMES GLEESON, 1960, Oct., 'Russell Drysdale'. With reproductions of three
 paintings previously unpublished, pp. 39–43.

The Australian Women's Weekly: Sydney.
 JO WILLIAMS, 1960, 5 Oct., 'The Artist who Loves to Hump his Bluey', inter-
 view, four colour reproductions, and a portrait photograph.

Pix: Sydney.
 F. W. L. ESCH, 1960, 8 Oct., 'Drysdale – His Paintings came Back', seven illus-
 trations, interview with artist.

Time: New York.
 1960, 10 Oct., pp. 41–45, 'Home Sweet Homeland', illustrated article on Dobell,
 Nolan and Drysdale.

The Bulletin: Sydney.
 1960, 12 and 19 Oct., review of the Retrospective Exhibition by D. S. (Douglas
 Stewart).

Nation: Sydney
 1960, 27 Oct., unsigned article (mostly by Max Harris) on Drysdale

Observer: Sydney.
 GEORGE BERGER, 1960, 29 Oct., review of the retrospective Exhibition.

Hemisphere: Sydney.
 DANIEL THOMAS, 1960, Nov., article on Drysdale with thirteen reproductions.

Quadrant: Sydney.
 MUNGO MACCALLUM, 1961, Winter, p. 84, 'Where now for Drysdale?'

Western Australian Art Gallery Bulletin.
 1966, Jan., 'Russell Drysdale', pp. 146–149.

Western Australian Art Gallery Monthly Feature.
 LOU KLEPAC, 1966, Jan., 'The Gatekeeper's Wife'.

FILMS

Russell Drysdale (21 minutes)

Commissioned by Qantas and made by Collings Productions. This was the first of three films by the same team, the second and third being *William Dobell* and *Sidney Nolan*.

It was produced by Geoffrey Collings and directed by Dahl Collings. Photography: Ron Horner; Editing: Judy Campbell; Music: Herbert Marks; Story: Laurie Thomas; Sound: Cliff Curll.

The film was shot in 35 mm Eastmancolour and recorded in Supreme Sound Studios, Sydney. The 16 mm release prints were made by Filmcraft Laboratories, Sydney. 16 mm prints are available on loan from Qantas representatives around the world.

Profile of Russell Drysdale

Australian Broadcasting Commission Television film. Produced by Gil Brearley, 1967.

List of Illustrations

17 Man Feeding his Dogs, 1941
Oil on canvas, 20 × 24 ins
Collection: Queensland Art
Gallery, Brisbane

18 Mother and Child, 1942
Oil on canvas, 29½ × 23½ ins
Collection: Mrs McClure
Smith

19 Going to the Pictures, 1941
Oil on canvas, 18 × 21½ ins
Collection: Clive Turnbull

20 Back Verandah, 1942
Oil on masonite, 16 × 20 ins
Collection: Queensland Art
Gallery, Brisbane

21 Local V.D.C. Parade, 1943
Oil on canvas, 17½ × 22½ ins
Collection: National Gallery
of South Australia

22 Albury Station, 1943
Oil on canvas, 24½ × 30 ins
Collection: National Gallery
of Victoria

23 Albury Platform, 1943
Gouache and ink,
21½ × 25½ ins
Collection: Miss Cecile Bel-
bridge

24 Woman Filing her Nails, 1943
Oil on canvas, 21⅝ × 15 ins
Collection: Art Gallery of
New South Wales

25 Portrait of Donald Friend, 1943
Oil on canvas, 24 × 20 ins
Collection: James Fairfax

26 Home Town, 1943
Oil on canvas, 20 × 24 ins
Collection: Miss Jean Stephen

27 Head of a Woman, c. 1942
Ink and chalk
Collection: Mr and Mrs W.J.
McLaughlin

28 Soldier with Three Children,
c. 1941
Pen, 7 × 6½ ins
Collection: National Gallery
of Victoria

29 Soldiers, c. 1943
Whereabouts unknown

30 Nude, c. 1941
Pen
Collection: W. Ritchie

31 Nude, c. 1941
Pen
Whereabouts unknown

32 Sketches for Soldiers Resting
Pen, 9¾ × 8 ins
Collection: the artist

33 Soldiers Resting, c. 1943
Collection: the artist

34 Ennui, 1944
Oil on canvas, 16 × 20 ins
Collection: Dr and Mrs Cedric
Swanton

35 Dead Horse, 1945
Oil on canvas, 16 × 12 ins
Collection: Miss Jean Stephen

36 Landscape with Figures, 1945
Oil on masonite, 24 × 30 ins
Collection: J. Landau

37 Mrs Gulotti, Country Pub
Kitchen, 1944
Pen
Collection: Mrs McClure
Smith

58 Portrait of Lynne, 1947
Oil on canvas, 24 × 20 ins
Collection: Miss Micheline
Drysdale

59 The Councillor's House, 1948
Oil on canvas, 32 × 40 ins
Collection: Sir Kenneth Clark

60 Margaret Olley, 1948
Oil on canvas, 23½ × 19½ ins
Collection: Kym Bonython

61 Picture of Donald Friend, 1948
Oil on canvas, 48 × 36 ins
Collection: Art Gallery of
New South Wales

62 Emus in a Landscape, 1950
Oil on canvas, 40 × 50 ins
Collection: Osborne Vary

63 George Ross of Mullengandra,
1950
Oil on canvas, 25½ × 39½ ins
Collection: Sir Philip Dunn

64 Mother and Son, North
Queensland, c. 1950
Oil on canvas, 40 × 50 ins
Collection: Mrs G. R. Drysdale

65 Children Dancing No. 2, 1950
Oil on canvas, 26 × 40 ins
Collection: Mervyn Horton

66 Children in a Bath, 1950
Oil on canvas, 20 × 24 ins
Collection: Mrs Francklyn
Thompson

67 Mount White, 1953
Oil on canvas, 26 × 40 ins
Collection: the artist

68 The Broken Mountain, 1950
Oil on canvas, 25¼ × 39½ ins
Collection: The Commercial
Banking Co. of Sydney,
London

69 War Memorial, 1950
Oil on canvas, 26 × 40 ins
Collection: The Tate Gallery,
London

70 Going to School, 1950
Oil on canvas, 20 × 30 ins
Collection: Atomic Energy
Research Establishment,
Harwell

71 Greenhide Jack at the Mailbox,
1950
Oil on canvas, 20 × 24 ins
Collection: Mrs Bryan Gibb

72 Anthills on Rocky Plain, 1950
Oil on canvas, 30 × 40 ins
Whereabouts unknown

73 Old Larsen, 1953
Oil on canvas, 36 × 28 ins
Collection: Mrs Douglas
Carnegie

74 Sketch of Aborigines, 1950s
Pen
Collection: the artist

75 Aboriginal Woman, 1950s
Pen
Collection: the artist

76 Desert Landscape, 1952
Oil on canvas, 40 × 50 ins
Collection: Art Gallery of
New South Wales

77 Shopping Day, 1953
 Oil on canvas, 24 × 30 ins
 Collection: T. B. Green

78 Mullaloonah Tank, 1953
 Oil on canvas, 48 × 72 ins
 Collection: National Gallery
 of South Australia

79 Station Blacks, Cape York,
 1953
 Oil on masonite, 23½ × 28 ins
 Collection: National Gallery
 of Victoria

80 Road to the Black Mountains,
 1952
 Oil on canvas, 20 × 24 ins
 Collection: Art Gallery of
 New South Wales

81 The Camp, 1953
 Oil on canvas, 30 × 64 ins
 Collection: Dr Byron Munroe

82 Young Man, 1953
 Oil on canvas, 16 × 20 ins
 Whereabouts unknown

83 Mother and Child, 1953
 Oil on canvas, 30 × 20 ins
 Collection: Newcastle City
 Art Gallery, New South Wales

84 Full Moon, 1953
 Oil on canvas, 30 × 40 ins
 Collection: Norman Mussen

85 Man with a Snake, 1950s
 Pen
 Collection: the artist

86–89 Aboriginal Women, 1950s
 Pen
 Collection: the artist

90 Saddling up at the Coen Races,
 1953
 Oil on canvas, 28 × 36 ins
 Collection: Mr and Mrs R. R.
 Russell

91 Young Station Boys, 1953
 Whereabouts unknown

92 Midnight Osborne, 1954
 Oil on canvas, 16 × 12 ins
 Collection: the Hon. Mr
 Justice Nagle

93 Boy with Lizard, 1955
 Oil on canvas, 28 × 36 ins
 Collection: Western Australia
 Art Gallery

94 Small Landscape, 1955
 Oil on canvas, 12 × 16 ins
 Whereabouts unknown

95 Portrait of a Girl, 1955
 Oil on canvas, 20 × 16 ins
 Collection: Queensland Art
 Gallery, Brisbane

96 Brandy John, 1956
 Ink wash
 Collection: John Douglas
 Pringle

97 Head, 1950s
 Pen
 Collection: the artist

98 Aboriginal Group, c. 1957
 Oil on canvas
 Collection: Colonel Aubrey
 Gibson

99 Basketball at Broome, 1958
 Oil on canvas, 29 × 49 ins
 Collection: J. Macallister

100 Youth at Broome, 1958
Oil on canvas, 30 × 50 ins
Collection: Colonel Aubrey
Gibson

101 Native Dogger at Mt Olga,
1958
Oil on canvas, 30 × 50 ins
Collection: Rupert Murdoch

102 The Red Shirt, 1958
Oil on canvas, 30 × 40 ins
Collection: Dr Mocatta

103 The Rainmaker, 1958
Oil on canvas, 30 × 24 ins
Collection: the artist

104 Malay Boy, Broome, 1959
Oil on canvas, 29 × 23 ins
Collection: A. I. Barrett

105 The Young Mourner, 1960
Oil on canvas, 36 × 28 ins
Collection: Reserve Bank of
Australia

106 The Puckamanni, 1958
Oil on canvas, 30 × 40 ins
Collection: Reserve Bank of
Australia

107 Chinese Boy, Darwin, 1958
Oil on canvas, 24 × 20 ins
Collection: Mrs G. R. Drysdale

108 Man with a Fish Spear, 1958
Oil on canvas, $39\frac{3}{4} \times 29\frac{3}{4}$ ins
Collection: Aberdeen Art
Gallery, Scotland

109 Kimberley Landscape, 1958
Oil on canvas, 30 × 50 ins
Collection: Sir Robert Adeane

110 Man and Woman, 1960
Oil on canvas, 50 × 40 ins
Collection: the artist

111 Mother and Child, 1963
Oil on canvas, 30 × 50 ins
Collection: James Fairfax

112 Red Landscape, 1958
Oil on canvas, 30 × 40 ins
Collection: Mrs Newbiggin
Watts

113 North Australian Landscape,
1959
Oil on canvas, 30 × 50 ins
Collection: Queensland Art
Gallery, Brisbane

114 The Woman Mangula, 1961
Oil on canvas, 40 × 30 ins
Collection: Sam Rubinsohn

115 Man in a Landscape, 1963
Oil on canvas, $35\frac{1}{4} \times 45\frac{1}{2}$ ins
Copyright reserved

116 Mangula, 1961
Oil on canvas, 72 × 48 ins
Collection: Art Gallery of
New South Wales

117 Ceremony at the Rock Face,
1963
Oil on canvas, 50 × 40 ins
Godfrey Phillips Ltd, Viscount
collection

118 Melville Island Lubra, 1960
Pen, 15 × 11 ins
Collection: Western Australia
Art Gallery, Perth

119 Standing Aboriginal Woman,
 1950s
 Brown ink and grey wash on
 paper
 Whereabouts unknown

120 Two Native Dancing Figures,
 c. 1960
 Oil on canvas
 Collection: Major Rubin

121 Study, 1961
 Whereabouts unknown

122 Mother and Child, 1961
 Oil on canvas, 50 × 30 ins
 Collection: Mr and Mrs G.R.
 Drysdale

123 Portrait, 1961
 Oil on canvas, 30 × 24 ins
 Collection: Mrs Rose Skinner

124 Bones of a Gold Town
 Drawing for 'Journey Among
 Men', 1961

125 Rocks at Gallery Hill
 Drawing for 'Journey Among
 Men', 1961

126 Moody's Bar, Hall's Creek,
 1961
 Pen
 Collection: Mrs A.J. Marshall

127 Mates, 1959
 Pen
 Collection: Rupert Murdoch

128 Old Timers of the Kimberleys
 Drawing for 'Journey Among
 Men', 1961

129 The Lovers, 1961
 Pen and wash
 Collection: the artist

130 Billy the Lurk, 1960
 Pen, 9 × 7 ins
 Collection: Geoffrey Dutton

131 Hawk and Hill, 1961
 Pen and wash
 Collection: the artist

132 Bush Children, 1961
 Pen
 Collection: Mrs A.J. Marshall

133 Birders, 1961
 Oil on canvas, 30 × 50 ins
 Whereabouts unknown

134 Birders in Bass Strait, 1961
 Oil on canvas, 30 × 50 ins
 Collection: Sir Frank Packer

135 Coming of the Mutton Bird,
 1959
 Mural drawing, 72 × 108 ins
 Collection: Dr W.W. Wood-
 ward

136 Old Harry, 1961
 Oil on canvas, 30 × 24 ins
 Collection: David McNicholl

137 Rocky McCormack, 1963
 Oil on canvas, 40 × 30 ins
 Collection: Rudy Komon

138 Girl at the Rockpool, 1963
 Oil on canvas, 50 × 40 ins
 Collection: V. Macallister

139 The Out-Station, 1965
 Oil on canvas, 30 × 50 ins
 Whereabouts unknown

140 Stockman, 1965
 Oil on canvas, 16 × 20 ins
 Collection: Mr and Mrs
 Geoffrey Collings

141 Walkabout, 1965
Oil on canvas, 30 × 50 ins
Collection: John Galvin

142 The Red Lady, 1965
Oil on canvas, 28 × 36 ins
Whereabouts unknown

143 The Mourner, 1967
Oil on canvas, 30 × 24 ins
Collection: Mrs Russell
Drysdale

144 Duststorm in the Central
Desert, 1968
Oil on canvas, 48 × 72 ins
Collection: Goldfields House,
Sydney

Index

All references are to page numbers; italic figures indicate illustrations